CHALK
ON THE
WILD SIDE

D1511938

Quarto is the authority on a wide range of topics.
Quarto educates, entertains, and enriches the lives of our readers—
enthusiasts and lovers of hands-on living.
www.quartoknows.com

Copy Editor: Jill Amack
Page Layout: Erin Fahringer

6 Orchard Road, Suite 100
Lake Forest, CA 92630
quartoknows.com
Visit our blogs @quartoknows.com

Printed in China
10 9 8 7 6 5 4 3 2 1

CHALK
ON THE
WILD SIDE

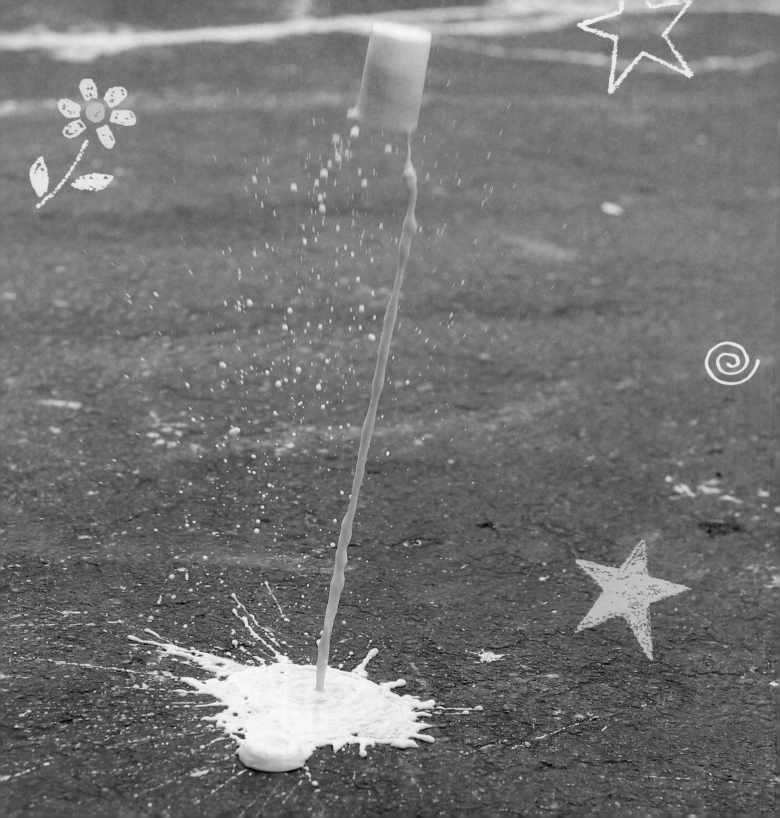

 # Table of Contents

Introduction

Chalk was a part of my childhood. I remember being given the job of clapping erasers for my first grade teacher. When a student was chosen for this prestigious job, he or she could choose a partner to help collect the chalkboard erasers and take them outside. Then we "cleaned" the erasers by slamming two of them together, creating big clouds of chalk dust. In those days, there were lots of erasers to clean because most of the classroom walls were lined with chalkboards. The whole room smelled like chalk, and teachers always had dust covering their clothing. Back then, students really did know the sound of "nails on a chalkboard!"

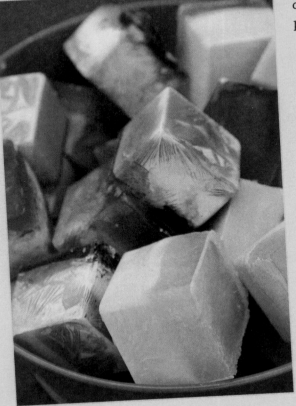

My favorite memories of chalk are more recent. They're not from my own childhood, but from my children's. Give them a bucket of sidewalk chalk and a place to draw, and my kids will entertain themselves for hours. They play hopscotch and write messages on the driveway. They draw pictures and trace each other's outlines. My favorite chalk recipes and activities are the ones that encourage this kind of creativity. I love to watch my kids express themselves and engage in make-believe while they're creating something with sidewalk paint or window chalk. Their favorite activities are the messy ones. They like sensory projects, such as ice chalk and exploding stomp chalk. Children learn best when all of their senses are engaged, and these chalk activities encourage exploration, descriptive language, and problem solving. But my kids don't know that. They're just having fun. Whatever kinds of activities you and your little ones prefer, this book is

full of chalk recipes and projects for adults and kids to explore together. Many of these activities are meant to be done outdoors, but I've also included some that can be done on a rainy or snowy day. If staining is a concern, choose washable paint for coloring and test first on an inconspicuous area. Don't be afraid to experiment and make substitutions or invent your own twist on a recipe. Due to variations in materials and temperatures depending on where you live or the time of year, I can't guarantee the exact results of your efforts, but there's always room for experimentation. Creating something is often as fun as enjoying the final product.

Although very few classrooms have actual chalkboards now, chalk is still a childhood classic and a great way to connect with kids of any age. I hope this book encourages you and your child to create some of your own chalk memories together.

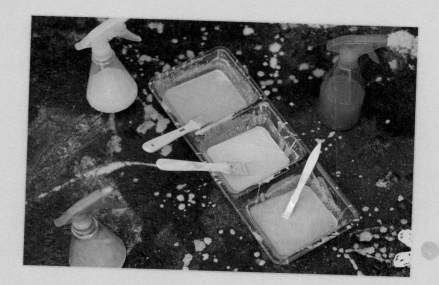

Tools & Materials

Plaster of Paris

Plaster of paris is the base for most homemade chalk recipes. It can be found online or in craft or home improvement stores. It's dangerous if inhaled or ingested, so be sure to follow the instructions on the label and only use with adult supervision.

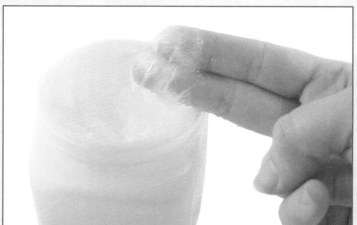

Nonstick Products

Petroleum jelly or nonstick cooking spray are used to help prevent chalk from sticking in the molds.

Molds

Candy molds, ice cube trays, muffin tins, and even toilet paper rolls can be used to give homemade chalk a variety of shapes. Silicone molds work especially well because they're less likely to stick.

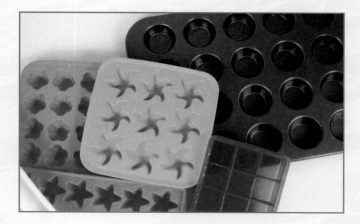

Coloring

Liquid watercolors, acrylic craft paint, liquid food coloring, and washable tempera paint are used to give color to chalk and can often be used interchangeably. If staining is a concern, opt for washable paint.

Thickeners

Cornstarch and flour can be found in any grocery store. They're used as thickeners in many of the recipes.

Soaps

Liquid hand soap and dishwashing liquid or detergent are used to make foam or bubbles. They can also be added to a recipe to make cleanup easier and staining less likely.

Scent

Unsweetened drink mix packets, baking extract, and essential oils are used to add scent to chalk.

Pantry Items

Vinegar, baking soda, and salt are likely found right in your kitchen cupboard. Baking soda and vinegar are used to produce a chemical reaction, while salt can be used to grind chalk into a powder.

Effervescent Antacid Tablets

Effervescent tablets can be purchased at drugstores, discount stores, or even dollar stores. The generic version works just as well as name brands for these activities. (Just make sure you don't eat them!)

Personal Care Items

Hair gel, shaving cream or foam, and baby oil are inexpensive and can be found at discount and dollar stores. They are used in chalk recipes such as hair chalk and bath chalk.

Sweet Stuff

Candy melts and fondant can be purchased at craft stores, online, or in some grocery stores. You can even try making your own!

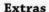

Chalk

In most cases, it doesn't matter if you use store-bought or homemade chalk. However, there is a difference between sidewalk chalk and chalkboard chalk. Unless specified, the recipes and activities in this book use sidewalk chalk.

Extras

Things like glitter, play sand, and sequins can be added to chalk for extra texture or visual appeal.

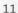

Drawing Techniques

Linear Strokes
Use the tip of the chalk (just as you would a pencil) to create thin lines and shapes.

Side Strokes
Use the side of the chalk to shade larger areas. Press lightly for less color, and apply more pressure for darker color.

Smudging
Color with chalk on the paper. Then rub it gently with a tissue, cotton ball, or paper towel.

Blending
Create subtle lines or shadows by using a cotton ball or your fingers to blur the edges of the chalk between two colors.

Color Mixing
Create new colors and effects by starting with one color of chalk and blending other colors over the top.

Hatching
To shade an area, draw many lines of chalk parallel to each other. The closer the lines are together, the darker the shading will appear.

Crosshatching
Begin by using the hatching technique, and then add more lines perpendicular to the first set. As with hatching, the closer the lines are, the more saturated the color will appear.

Gradation
Gradually increase the pressure used on the chalk to increase the saturation of color, or gradually decrease the pressure to make the color more subtle.

Wet Chalk
Soaking chalk in water before use will give it a creamier texture, more saturated color, and smoother application. Wetting the paper will have a similar effect.

Chalk Pastels

Unlike oil pastels, which are oil-based, chalk pastels are made primarily of chalk. There are a variety of chalk pastel shapes and sizes, and they also range from hard to soft.

✳ TIP ✳

Chalk is very easy to smudge, so be sure to keep your hands off the paper

Sidewalk Chalk

Sidewalk chalk is usually longer and thicker and is often made up of rougher material which may scratch the surface of some chalkboards. It is made to be used on concrete or pavement. Try using it both dry and wet for different color effects!

Chalkboard Chalk

Chalkboard chalk is usually longer, thinner, and softer and may not stand up well on the rough surfaces outside. Although once made of calcium carbonate, most chalks are now made from the mineral calcium sulfate.

Paper Texture

Create different effects with different paper textures. The rougher the paper, the more chalk will be transferred in a single stroke.

Smooth Paper

Textured Paper

Laid Paper

Watercolor Paper

Paper Color

Colored paper can help make your drawings more realistic. See how easy it is to draw a round ball using just black and white chalk on gray paper?

Use black to lightly draw a circle.

Color a "C" shape for the shadow. Add a white highlight on the top right side.

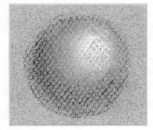

Blend the chalk in a circular motion.

✶ TIP ✶
Try sandpaper for especially vibrant chalk drawings.

Chalk & Paper

You don't need fancy materials to have fun with chalk. Grab a sheet of paper and use it to create a work of art. Chalk drawings look especially vibrant on dark-colored paper. When you're finished, have an adult spray your drawing with hair spray to help set the chalk and prevent it from rubbing off. For more ways to have fun with chalk and paper, try one (or more!) of these chalk-and-paper art projects. Don't be afraid to experiment and invent your own techniques. Use your imagination—the things you can create with chalk and paper are limitless.

SUPPLIES
- Chalk
- Thick paper, like card stock or watercolor paper

ADDITIONAL SUPPLIES
- Water
- Paintbrush
- Painter's tape
- Sandpaper
- Cotton balls
- Sugar
- White school glue
- Food coloring or liquid watercolor paint
- Liquid starch
- Black paper
- Paint

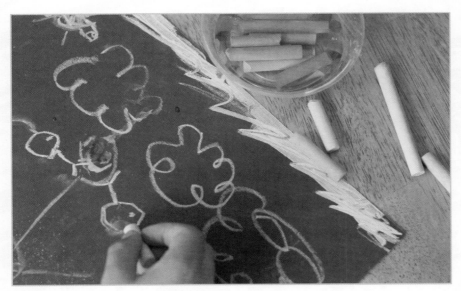

1. Wet Chalk vs. Dry Chalk
Experiment with regular dry chalk and chalk that's been soaked in water. The wet chalk is much darker and more vibrant.

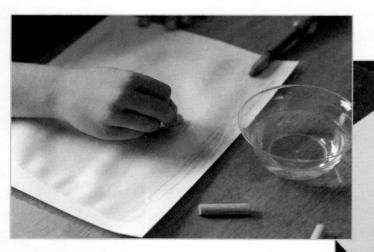

2. Wet Paper Chalk

Rather than wetting the chalk, try wetting the paper first with a paintbrush. Use thick paper for this activity so it won't tear.

3. Chalk Rubbing

This classic activity takes advantage of different textures. Simply find something with an interesting pattern, place it under a piece of paper, and rub the top of the paper with chalk to transfer it. Thin paper works best for this project.

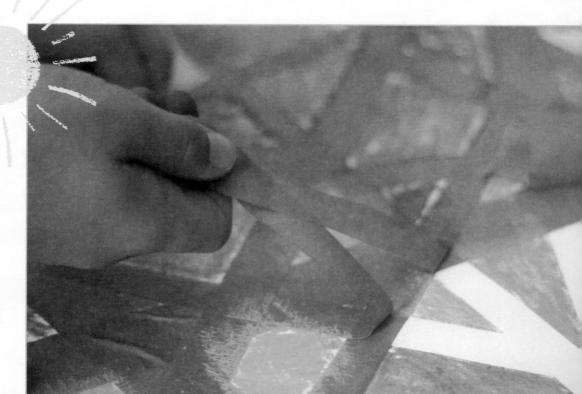

4. Tape Resist Chalk

Place painter's tape in a pattern on a piece of paper. Use wet chalk to color between the lines. When finished, carefully remove the tape to reveal your design.

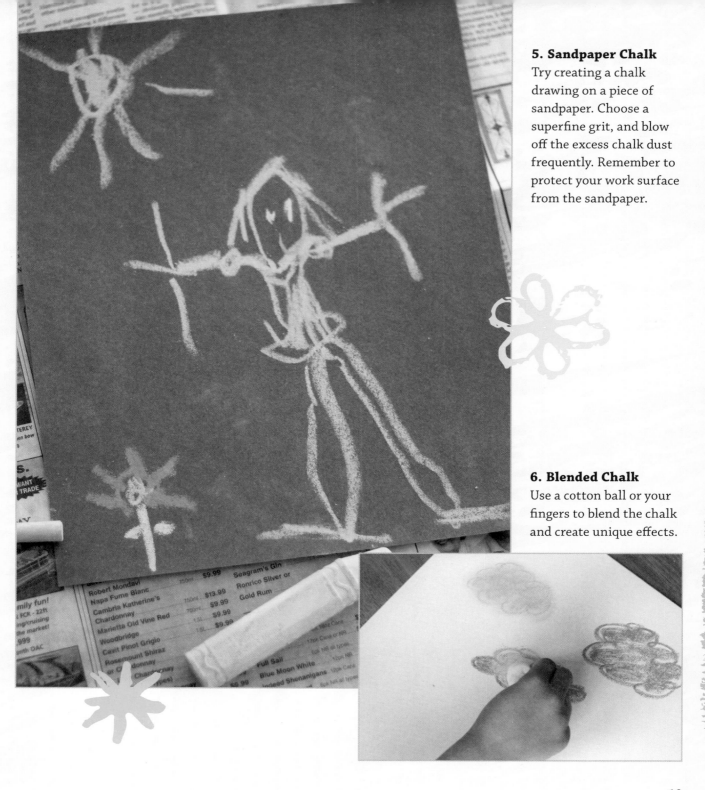

5. Sandpaper Chalk

Try creating a chalk drawing on a piece of sandpaper. Choose a superfine grit, and blow off the excess chalk dust frequently. Remember to protect your work surface from the sandpaper.

6. Blended Chalk

Use a cotton ball or your fingers to blend the chalk and create unique effects.

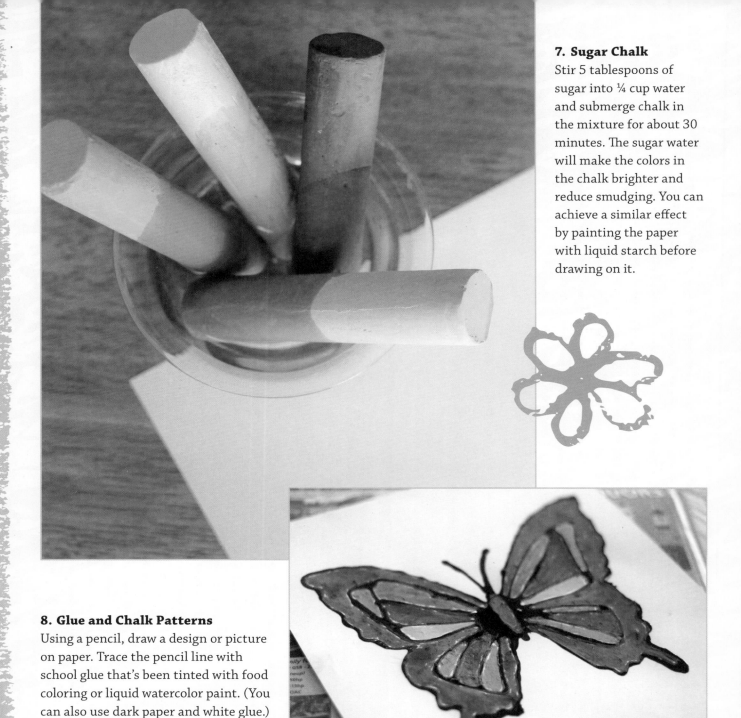

7. Sugar Chalk

Stir 5 tablespoons of sugar into ¼ cup water and submerge chalk in the mixture for about 30 minutes. The sugar water will make the colors in the chalk brighter and reduce smudging. You can achieve a similar effect by painting the paper with liquid starch before drawing on it.

8. Glue and Chalk Patterns

Using a pencil, draw a design or picture on paper. Trace the pencil line with school glue that's been tinted with food coloring or liquid watercolor paint. (You can also use dark paper and white glue.) After allowing the glue to dry, color the picture with either wet or dry chalk.

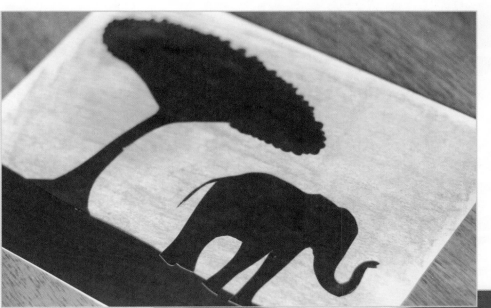

9. Silhouette Chalk Scene

Chalk makes a great background for silhouettes cut from black paper. Try creating a sunset or ocean scene.

✳ Tip ✳

Although they are made with similar ingredients, sidewalk chalk and chalkboard chalk are different. Besides being generally longer and thicker, sidewalk chalk usually contains particles that would scratch the surface of a chalkboard. Either type of chalk is great to use for paper projects.

10. Chalk and Paint

Dip brightly colored chalk in white or black paint before drawing with it. The paint will give the chalk more dimension.

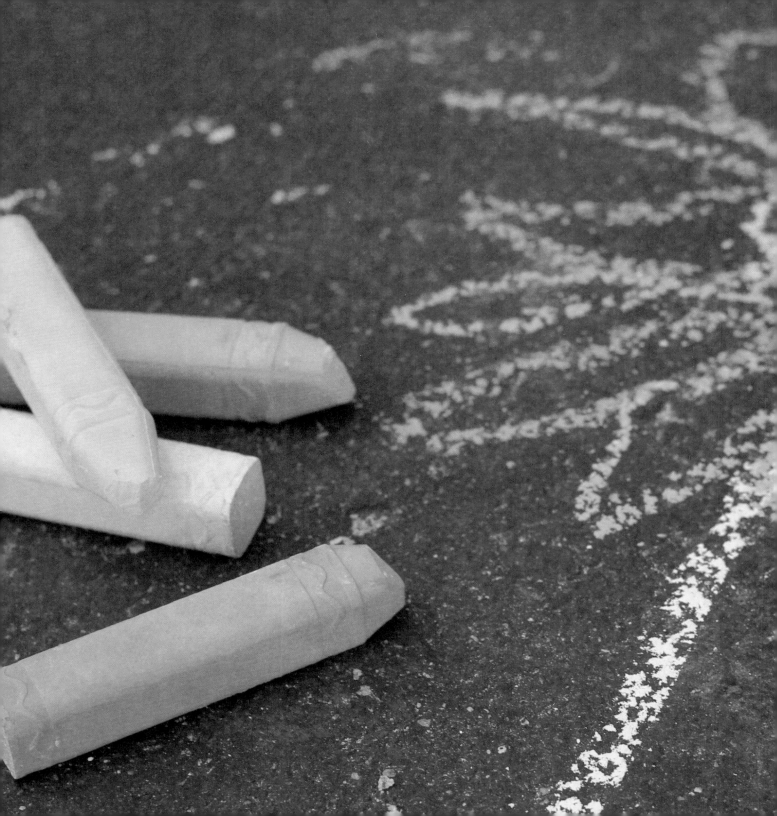

Chalk & Pavement

Drawing on the pavement with sidewalk chalk is a classic summer pastime, so grab some chalk and get outside. Draw a picture or write a message. Use the chalk to trace objects with interesting shapes or to create life-size drawings. Whether you have a small slab of pavement or a huge driveway, get out your chalk and make the most of it!

SUPPLIES
- Sidewalk chalk
- Driveway or pavement

ADDITIONAL SUPPLIES
- Water
- Paintbrush
- Camera
- Beanbags
- Water balloons

1. Disappearing Chalk
Use chalk to color a block of pavement. Use a paintbrush dipped in water to draw a picture or write a message inside.

2. Chalk Scene

Draw a scene with chalk, position yourself in the center of the action, and take a picture.

3. Obstacle Course

Make an obstacle course using chalk. Draw a line that participants must follow. Be sure to include lots of twists and turns. Add some commands like "Turn Around" or "Jump!"

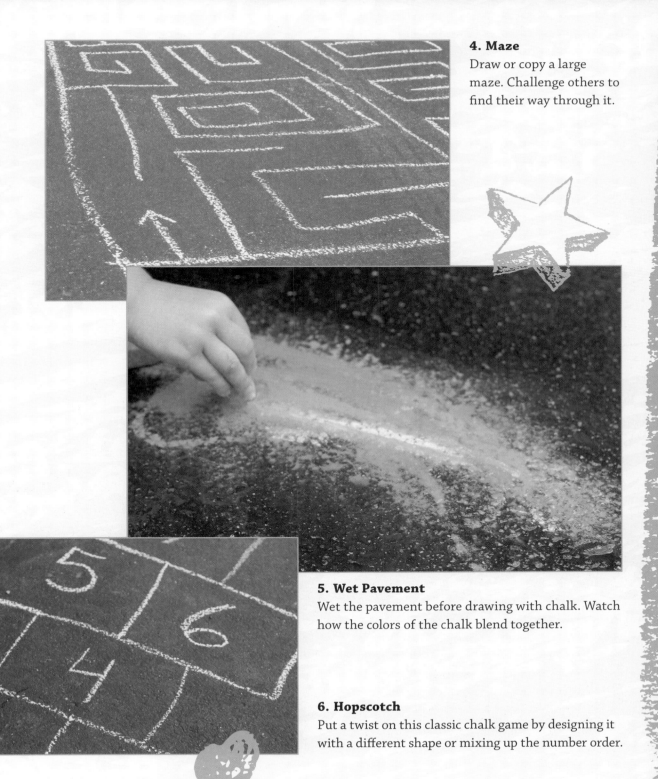

4. Maze

Draw or copy a large maze. Challenge others to find their way through it.

5. Wet Pavement

Wet the pavement before drawing with chalk. Watch how the colors of the chalk blend together.

6. Hopscotch

Put a twist on this classic chalk game by designing it with a different shape or mixing up the number order.

7. Chalk Shadows

Grab a partner and strike a crazy pose in the sunlight. Take turns tracing each other's shadow.

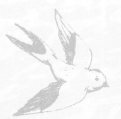

8. Chalk Targets

Use chalk to draw targets. Make different kinds: bull's-eyes, shapes, or letters. Throw beanbags or water balloons and try to hit the targets. (See page 112 for chalk bombs—a perfect recipe to use with targets!)

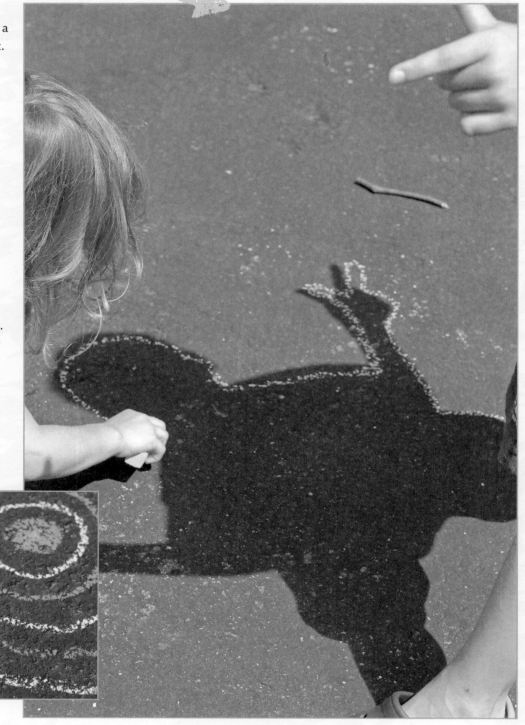

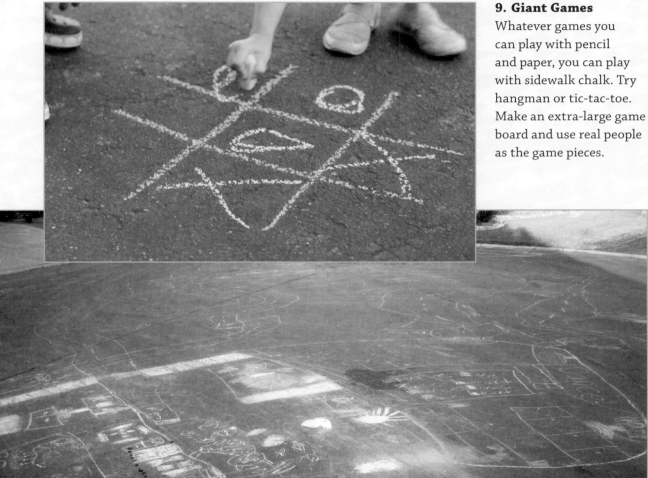

9. Giant Games

Whatever games you can play with pencil and paper, you can play with sidewalk chalk. Try hangman or tic-tac-toe. Make an extra-large game board and use real people as the game pieces.

10. Chalk Places

Design a home or castle with many different rooms or a town with lots of roads and buildings.

27

Homemade Sidewalk Chalk

Making your own sidewalk chalk is almost as much fun as drawing with it. It's easy, inexpensive, and can be made in any shape or color. The hardest part of this project is waiting for the chalk to dry! This recipe makes approximately two standard sticks of sidewalk chalk in a single color.

INGREDIENTS
- 2-3 tablespoons washable tempura paint
- ⅓ cup water
- ½ cup plaster of paris*

It's important to handle plaster of paris carefully and with adult supervision. Avoid getting it in your eyes or inhaling it. Wear eye protection, gloves, and a mask if necessary. Be sure to read the label before using. It should never be poured down the sink.

SUPPLIES
- Cardboard tubes (from toilet paper, paper towels, or wrapping paper)
- Scissors
- Duct tape
- Wax paper
- Disposable cup
- Disposable spoon or craft stick for stirring
- Resealable sandwich bag

DIRECTIONS

1. Depending on the size you'd like your chalk, you may have to adjust the size of the cardboard tubes. If they're too long, use scissors to cut them shorter. If they're too thick, remove a strip of cardboard from the tube by making two cuts lengthwise.

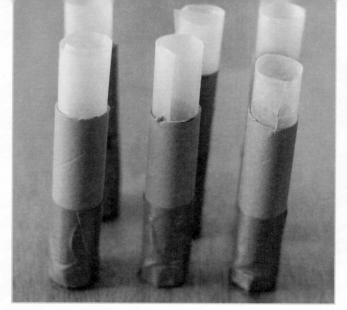

2. Use a piece of duct tape to secure the two sides together, making sure to seal the seam completely. Cover one end of each cardboard tube with duct tape. Line each tube with a small sheet of wax paper cut to size. This will keep the chalk from sticking to the cardboard tube.

3. In a disposable cup, stir together the water and paint until thoroughly combined. Add the plaster of paris, and then mix well.

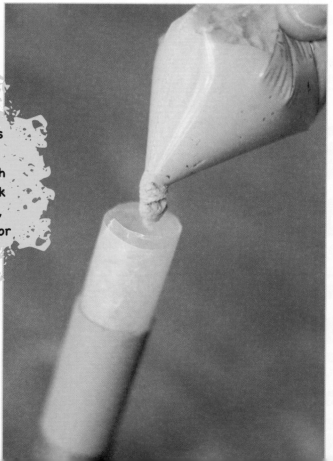

✷ TIP ✷

You can make chalk in different shapes using premade molds. Be sure to coat the inside of the molds generously with petroleum jelly before adding the chalk mixture. Ice cube trays, silicone molds, and candy-making trays all work well for making unique chalk shapes.

4. Pour the mixture into a sandwich bag and seal. Snip off one corner of the bag, and pipe the mixture into each cardboard tube. Dispose of the container you used to mix the plaster in the trash. (Do not pour plaster of paris down the sink because it will clog the pipes!)

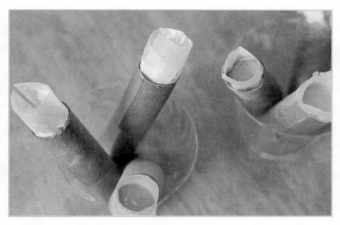

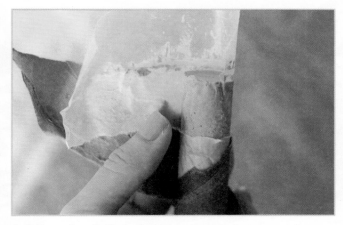

5. Tap the mold gently on a hard surface to settle the chalk mixture and to release any air bubbles. Allow the chalk to dry for a few hours.

6. When the chalk feels firm, remove the tape, tube, and wax paper.

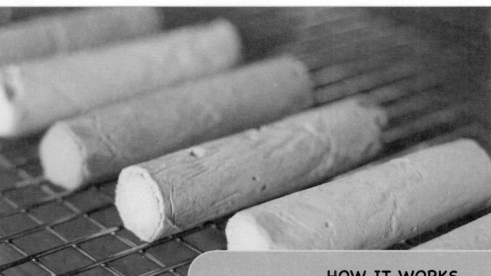

7. Allow the chalk to dry on a rack for at least 24 hours before using it.

HOW IT WORKS

After the mixture is poured into the molds, touch the outside of the cardboard tube at regular intervals to see if it's warm. Any increase in temperature you feel is caused by a chemical reaction called an *exothermic reaction*, which releases energy in the form of heat. This occurs when water is mixed with plaster of paris. Once the plaster has hardened, it will no longer release heat.

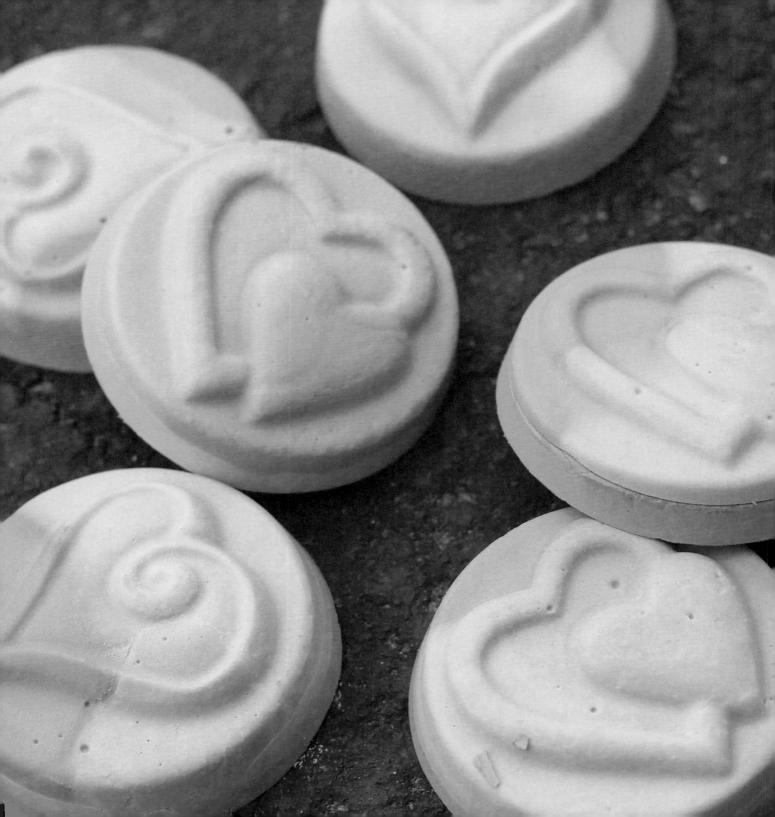

Multicolored Chalk

Why settle for one color of chalk when you can have them all in a single piece? Multicolored chalk is simple to make and can be customized using ice cube trays or candy-making molds. Clear trays work well for making swirled multicolored chalk because you can see through the bottom. Make a variety of fun shapes and colors, and don't forget to make extra to give away as party favors or gifts!

INGREDIENTS
- Cooking spray or petroleum jelly
- 2 tablespoons water
- 4-5 tablespoons plaster of paris*
- Liquid food coloring

*It's important to handle plaster of paris carefully and with adult supervision. Avoid getting it in your eyes or inhaling it. Wear eye protection, gloves, and a mask if necessary. Be sure to read the label before using. It should never be poured down the sink.

SUPPLIES
- Ice cube tray or candy mold
- Disposable cup or bowl
- Disposable spoon or craft stick for stirring
- Toothpicks (optional)

DIRECTIONS
1. Spray the mold with cooking spray, or grease it with petroleum jelly. This will keep the finished chalk from sticking. Set aside.

2. Pour the water into a disposable container. Stir in the plaster of paris a tablespoon at a time until the mixture has the consistency of pudding. It should be thick enough so it isn't runny, but not so thick you can't mix it. If the mixture is too thin, the colors will run together when poured into the mold. Tint the chalk with the food coloring. Repeat for each color.

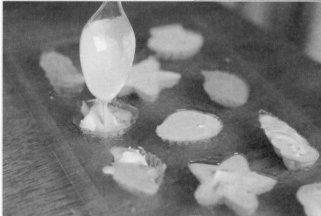

3. Place a little of each color into the molds. Keep in mind that as the chalk mixture sits it will begin to thicken and set. Don't wait too long to put the colored mixtures into the molds. Tap the mold gently on a hard surface to release air bubbles and to fill any spaces in the molds.

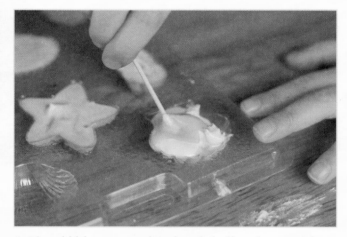

4. If you'd like your multicolored chalk to have swirls, use a toothpick to gently mix the colors. Don't overmix or you won't be able to see the swirls.

5. Allow the chalk to harden before releasing it from the molds, at least several hours. Once you've removed it, allow it to dry for a few more hours before using.

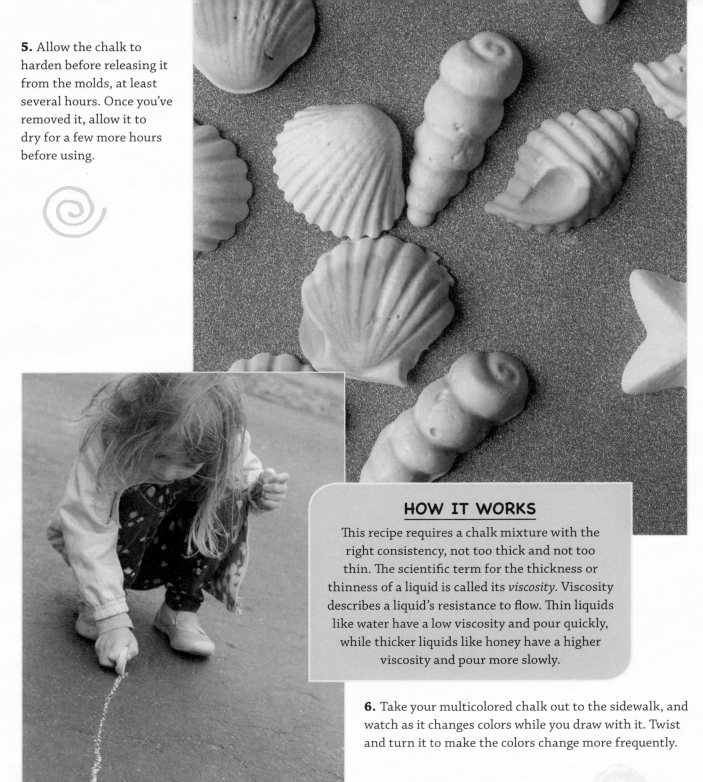

HOW IT WORKS

This recipe requires a chalk mixture with the right consistency, not too thick and not too thin. The scientific term for the thickness or thinness of a liquid is called its *viscosity*. Viscosity describes a liquid's resistance to flow. Thin liquids like water have a low viscosity and pour quickly, while thicker liquids like honey have a higher viscosity and pour more slowly.

6. Take your multicolored chalk out to the sidewalk, and watch as it changes colors while you draw with it. Twist and turn it to make the colors change more frequently.

Scented Chalk

This recipe uses baking extract to make sidewalk chalk that smells as pretty as it looks. Extracts are available in the baking or spice aisle of the grocery store and come in flavors such as vanilla, mint, and lemon. Because they may contain a high percentage of alcohol, extracts should be used with adult supervision. You can also substitute a few drops of essential oil for the extract. Just be sure that the oil you choose is safe for kids. Lavender (*Lavandula angustifolia*) is a great choice and a relaxing scent.

INGREDIENTS
- Petroleum jelly
- ⅓ cup water
- ½ cup plaster of paris*
- 1-2 teaspoons extract or essential oil
- Food coloring or washable paint

It's important to handle plaster of paris carefully and with adult supervision. Avoid getting it in your eyes or inhaling it. Wear eye protection, gloves, and a mask if necessary. Be sure to read the label before using. It should never be poured down the sink.

SUPPLIES
- Ice cube tray or mold
- Paper towel
- Disposable cup or bowl
- Disposable spoon or craft stick for stirring
- Measuring cups and spoons

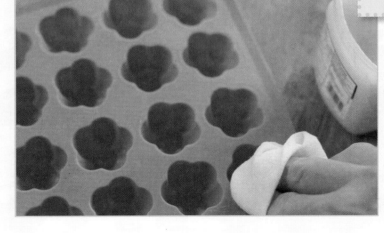

DIRECTIONS
1. Use the paper towel to apply a thin layer of petroleum jelly to the mold. This will prevent the chalk from sticking. Set aside.

2. Pour water into a disposable container. Add plaster of paris, and stir until smooth.

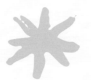

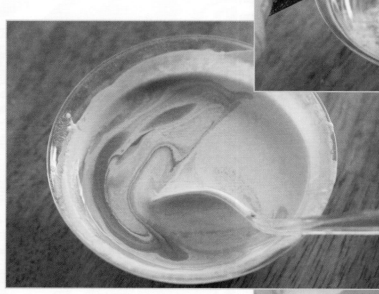

3. Add extract or essential oil, and tint the chalk using food coloring or paint. Stir.

4. Spoon the chalk mixture into the molds. Tap the mold gently on a hard surface to settle the chalk.

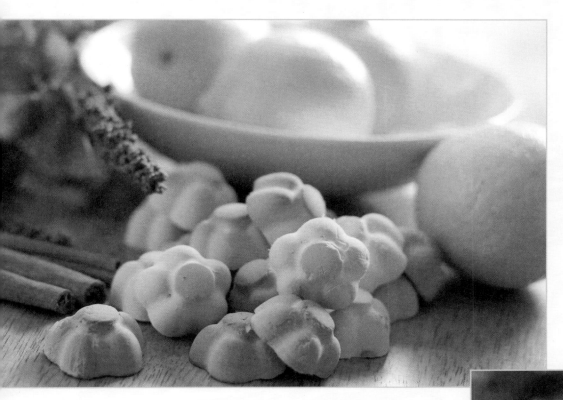

5. Allow the chalk to harden before releasing it from the mold, at least a few hours. It will still be soft, but it will become harder after another day of drying.

HOW IT WORKS

Humans can detect thousands of different smells thanks to special cells in our noses. Most animals have even more of these cells, making them better sniffers than humans. The African elephant can detect water from miles away, and an albatross can smell fish from the air.

6. Your chalk will smell wonderful even before it's finished drying. Flavors and extracts come in a wide variety, including cinnamon, coconut, coffee, and even chocolate, so you can experiment with lots of different scents.

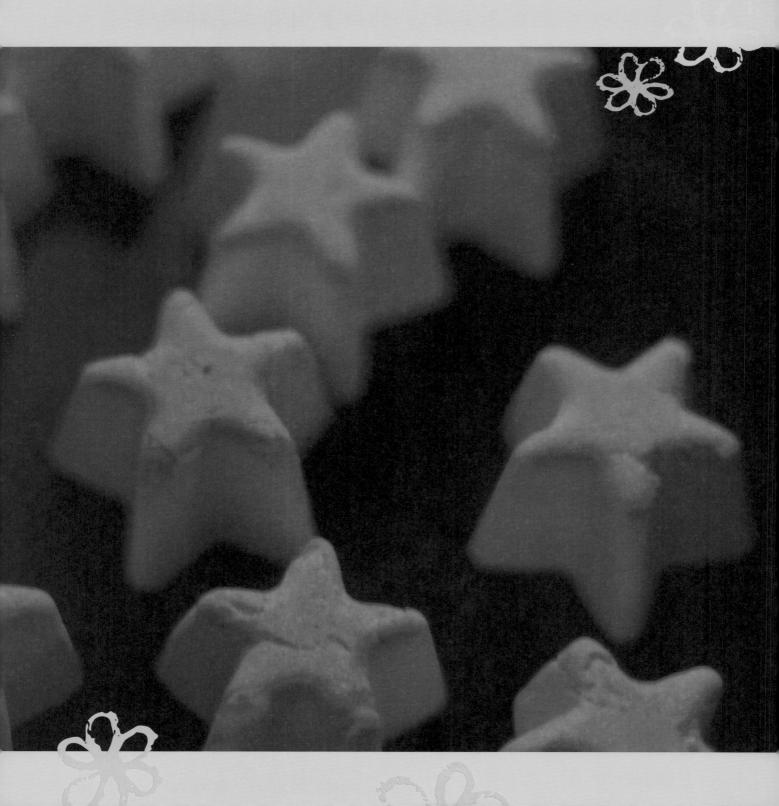

Glow Chalk

This glow-in-the-dark chalk is fun to play with, whether day or night. Although it looks like regular chalk when the sun is shining, it begins to glow as soon as darkness falls. Use it to make a starry scene in your driveway, or try marking trees and rocks to create a trail you can see in the dark.

INGREDIENTS
• Petroleum jelly or cooking spray
• 3 tablespoons washable glow-in-the-dark paint
• ⅓ cup water
• ½ cup plaster of paris*
• 1 tablespoon glitter (optional)
• 1 tablespoon washable colored paint (optional)

*It's important to handle plaster of paris carefully and with adult supervision. Avoid getting it in your eyes or inhaling it. Wear eye protection, gloves, and a mask if necessary. Be sure to read the label before using. It should never be poured down the sink.

SUPPLIES
• Ice cube tray or mold
• Paper towel
• Disposable bowl
• Disposable spoon or craft stick for stirring

DIRECTIONS
1. Use the paper towel to apply a thin layer of petroleum jelly to the mold, or spray the mold with cooking spray. Be sure to thoroughly cover the inside of each mold so the chalk doesn't stick.

41

2. Pour the glow-in-the-dark paint into the disposable bowl. Add water and stir until blended.

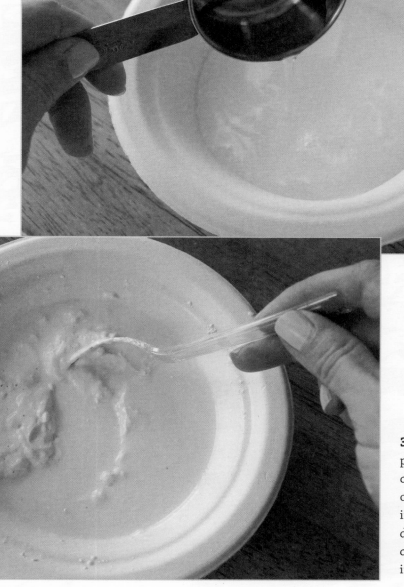

3. Add the plaster of paris and stir. You can also add glitter or color at this time if you choose. If you don't add color, the chalk will look white in the daylight.

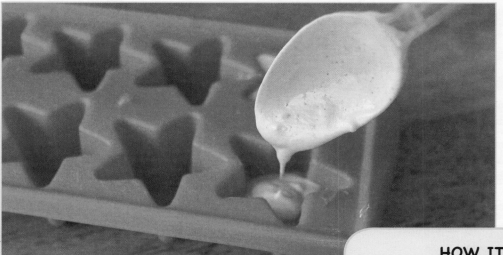

4. Carefully spoon the chalk mixture into the molds. Tap the mold gently on a hard surface to settle the mixture and release any air bubbles.

HOW IT WORKS

A process called *photoluminescence* is what gives glow-in-the-dark paint its glow. Though it does not actually contain light, it has a pigment called *phosphor* that soaks up tiny particles of light, or photons, when it's exposed to the sun. After it's energized, you can see the photons in the dark because they emit a phosphorescent glow.

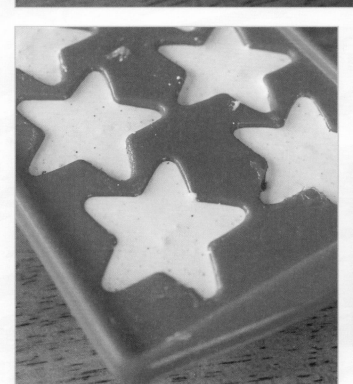

5. Allow the chalk to set for several hours. When it feels hard, remove from the mold and place the chalk in a sunny spot for several more hours.

6. Use your glow-in-the-dark chalk just as you would use regular sidewalk chalk. Wait for the sun to set, and enjoy the glow from your creations. A UV black light flashlight or lantern will enhance the glow from your chalk and can be purchased at your local hardware store.

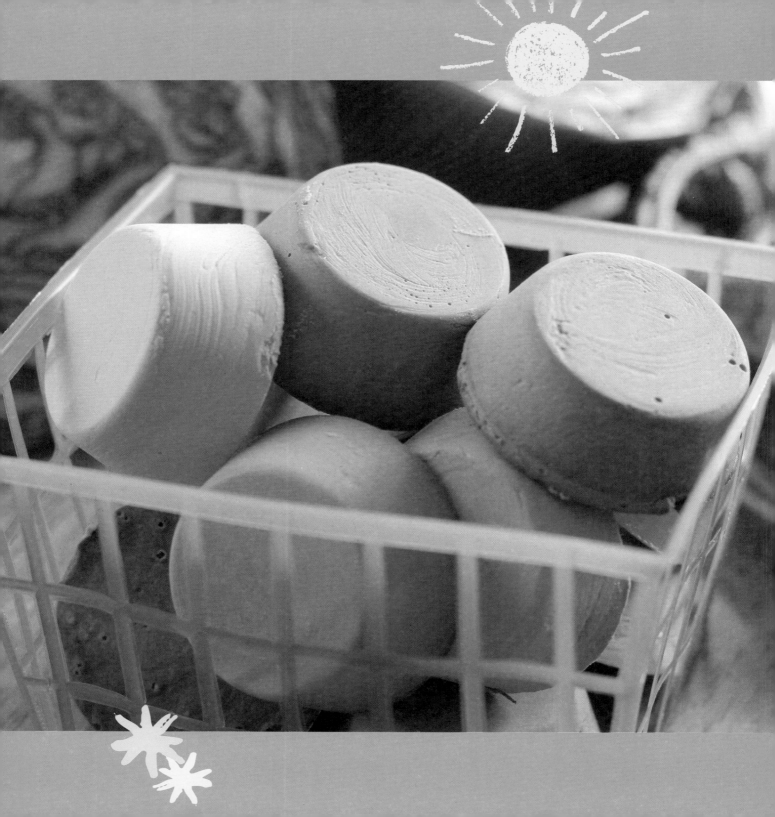

Veggie Chalk

Didn't eat your vegetables? Instead of throwing them away, use them to make a natural dye for homemade chalk! This is a fun way to experiment with creating dyes. If you don't have leftovers, the inedible parts of vegetables, such as the peel and outer leaves, also work well. As an alternative, using the juice from canned vegetables saves time and doesn't require cooking. If you do use the stove (or a knife) for this recipe, it's important to do so only with adult supervision.

INGREDIENTS
- Petroleum jelly
- 1 cup each of fresh beets, spinach, and red cabbage or 1 can of each vegetable (without additives)
- 6 cups water
- About 2 cups plaster of paris*

It's important to handle plaster of paris carefully and with adult supervision. Avoid getting it in your eyes or inhaling it. Wear eye protection, gloves, and a mask if necessary. Be sure to read the label before using. It should never be poured down the sink.

SUPPLIES
- Paper towel
- Mold
- Cutting board and knife
- 3 saucepans
- Cheesecloth or fine strainer
- Mixing bowls and measuring spoons
- 3 disposable cups and spoons

DIRECTIONS

1. Grease a mold with petroleum jelly.

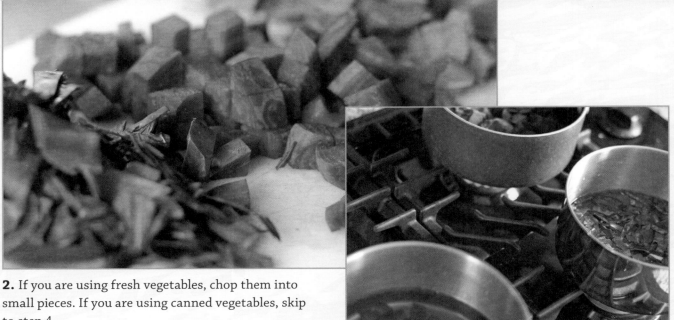

2. If you are using fresh vegetables, chop them into small pieces. If you are using canned vegetables, skip to step 4.

3. Place each vegetable into a separate saucepan, and cover with 2 cups of water. Simmer the vegetables over very low heat for one hour. Watch the pots carefully.

4. Drain the vegetables using a fine strainer or cheesecloth. Be sure to catch the juice in a bowl. Measure out ⅓ cup of each juice, and pour into a disposable container.

HOW IT WORKS

The color of a fruit or vegetable tells you about its nutritional value. Red fruits and vegetables get their color from lycopene, an antioxidant believed to protect against cancer. Orange and yellow produce is rich in beta-carotene, which keeps eyes, skin, and bones healthy. A green color indicates a vegetable is likely high in iron, while blue and purple fruits and vegetables contain lots of antioxidants. That's why eating a variety of colorful fruits and vegetables every day helps you stay healthy.

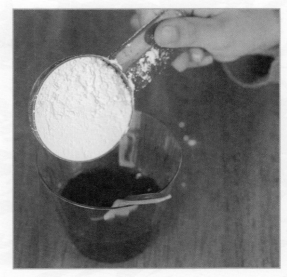

5. Add ½ cup plus 2 tablespoons of plaster of paris to each cup and mix thoroughly.

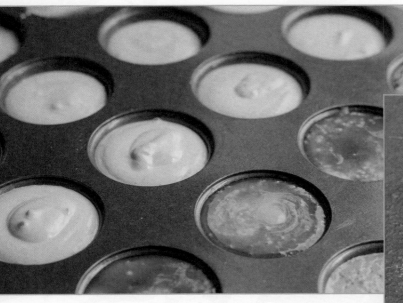

6. Spoon each mixture into the mold.

7. Let the chalk set until it becomes hard, at least 24 hours. (Depending on the ingredients, this chalk may not keep for quite as long as other types of chalk, so get out there and use it!)

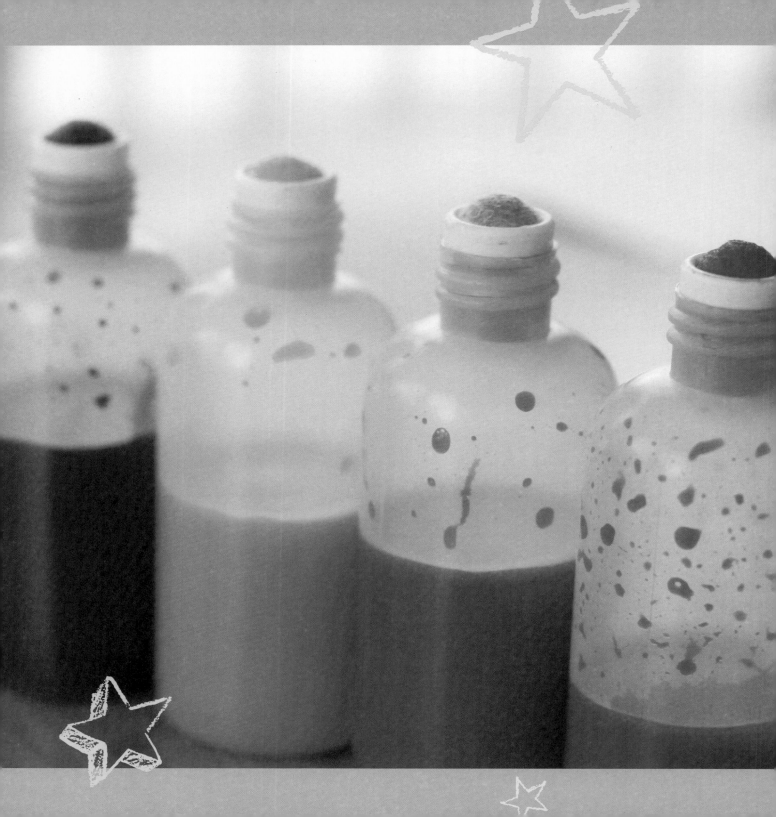

Liquid Window Chalk

Decorate any glass surface using a batch of this easy-to-make window chalk. With ingredients similar to homemade glass cleaner (minus the paint), it will leave your windows or mirrors cleaner than before they were painted! Refillable bingo markers make this activity less messy and can be found at online party supply stores. You can also purchase empty bottles and spouncer tops from craft supply stores or simply use foam brushes to apply the paint to the glass.

INGREDIENTS
- 1 teaspoon vinegar
- ½ teaspoon cornstarch
- 2 tablespoons washable liquid watercolor paint, any color

SUPPLIES
- Refillable bingo markers
- Small funnel
- Mixing bowl and spoon
- Measuring spoons

DIRECTIONS

1. Combine the vinegar and cornstarch.

2. Add the watercolor paint and mix well. Use a funnel to transfer the mixture into a refillable bingo bottle. Insert the top of the marker.

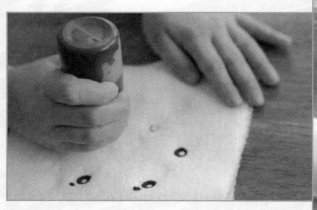

3. Press the end of the marker on a paper towel until it begins to dispense color. Repeat for each color.

4. Use the bingo bottle as you would a marker to apply the paint to the glass. If the paint is dripping, apply less pressure to the marker. If not enough paint is dispensed, apply more pressure.

5. Keep the caps on your window markers when they're not in use. If you haven't used them in a while, give the bottles a shake before you use them to paint.

6. Use the window chalk to decorate any glass surface—patio doors, mirrors, or even car windows. The colors will look more like chalk as they dry.

HOW IT WORKS

Paint gets its color from tiny pigment particles. There are three kinds of watercolor paint—tube paint, pan paint, and liquid paint. This recipe uses liquid watercolor paint, which has already been diluted with lots of water.

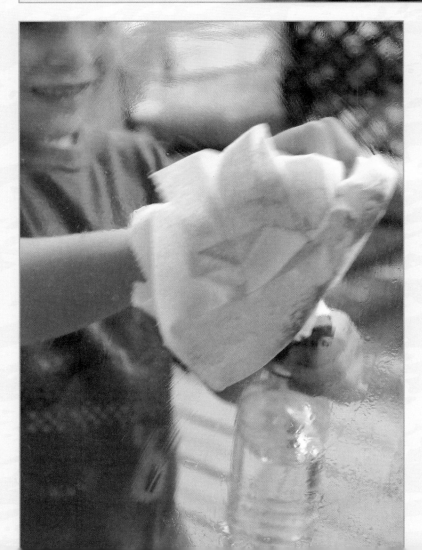

7. To remove your chalk designs, fill a spray bottle with water. Spray the glass, and use paper towels to wipe until clean. If needed, add vinegar to the spray bottle so the mixture is half vinegar and half water.

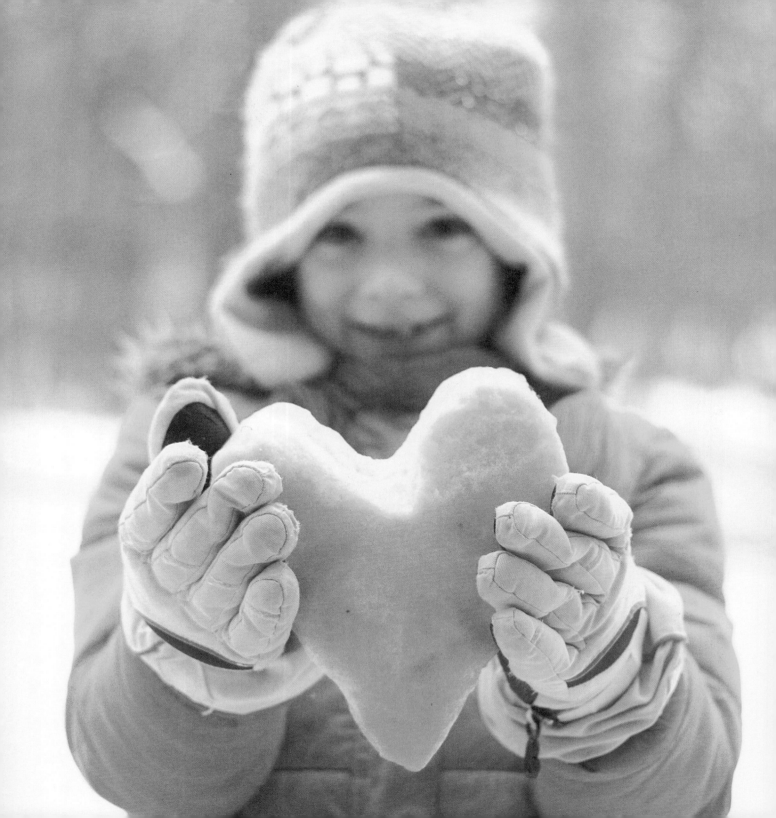

Any-Day Chalk Spray

The best thing about chalk spray is that children can use it any time of year, from a snowy winter afternoon to a hot summer day. It can decorate snowmen and ice sculptures just as beautifully as sidewalks and pavement. Using washable paint ensures that mittens, hands, and clothes won't get stained.

INGREDIENTS
- 2 cups warm water
- 1 teaspoon flour
- 1-2 tablespoons washable paint

SUPPLIES
- Empty spray bottles
- Measuring cups and spoons
- Mixing bowl and spoon

DIRECTIONS
1. Pour 2 cups of warm water into a bowl. Add flour and stir until dissolved. Use a whisk to get rid of any lumps.

2. Mix in 1 to 2 tablespoons of washable paint. Keep adding paint until the desired color is reached. For more vibrant color, add more paint. Bold, bright colors work best for this project.

3. Pour the mixture into an empty spray bottle. For larger spray bottles, you can double the batch.

4. Repeat for each color of spray. Periodically shake the bottle while in use to keep the contents from settling at the bottom. If the nozzle clogs, run it under warm water.

5. You can use Any-Day Chalk Spray just about anywhere. Try decorating a snowman or making colorful snowballs for a snowball fight. No snow? No problem. It also works on pavement and driveways and will dry to a chalky finish in no time. The possibilities are endless!

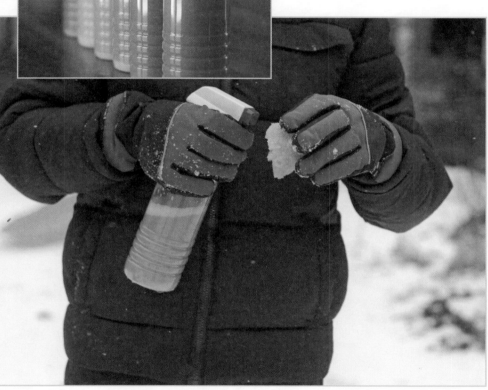

HOW IT WORKS

Whatever the weather, you can use chalk spray to observe changing states of matter. On a hot summer day, the water in the chalk spray will evaporate quickly and change from a liquid to a vapor. On a cold winter day, the water in the chalk spray might freeze and change from a liquid to a solid. Both of these changes occur because of energy added (like increasing the temperature) or energy taken away (like decreasing the temperature).

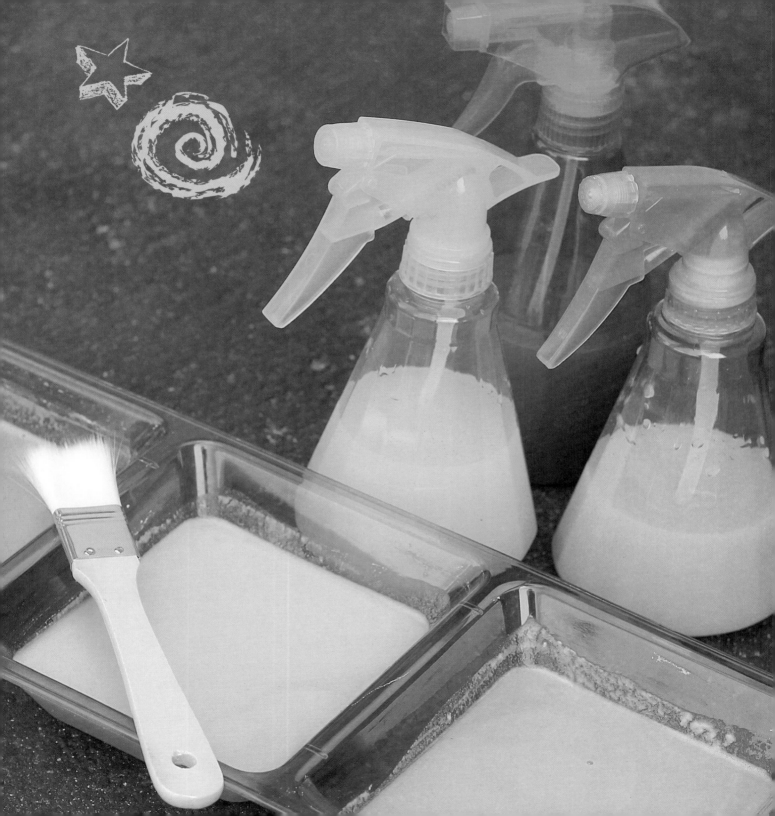

Color-Changing Sizzle Paint

This sidewalk chalk paint might not actually be magical, but it sure seems like it. There are two parts—the chalk paint and the spray. First brush the chalk paint onto a driveway or sidewalk, and then use the spray to make the paint sizzle and change color. The spray will work whether the chalk paint is wet or dry. As an alternative, you can make the spray using vinegar and food coloring, but it won't smell nearly as good!

INGREDIENTS

For the paint:
- 1½ cups water
- ¾ cup flour
- 1 cup baking soda
- 15-25 drops of food coloring in red, yellow, and blue

For the spray:
- 3 cups water
- 3 small packets of unsweetened drink mix in red, blue, and yellow flavors

SUPPLIES
- 3 bowls
- Measuring cups
- Whisk or fork
- Mixing spoons
- 3 spray bottles
- Paintbrushes

✳ TIP ✳

There's a lot of food coloring in this recipe, so be extra careful about staining. Wear play clothes and test a small area of the surface you'll be using to be sure the paint will wash off.

DIRECTIONS

1. Pour ½ cup of water into each of the three bowls. Add ¼ cup of flour to each bowl, and use a fork or whisk to stir until smooth.

57

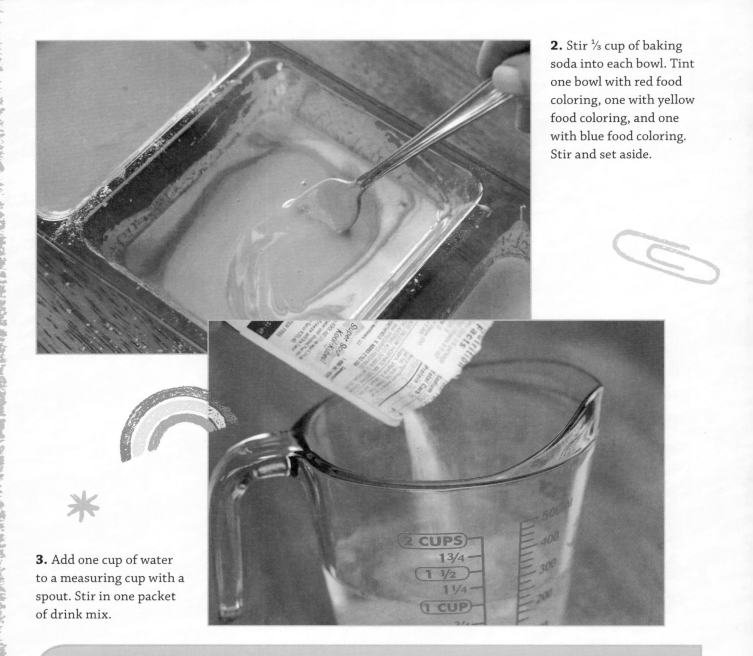

2. Stir ⅓ cup of baking soda into each bowl. Tint one bowl with red food coloring, one with yellow food coloring, and one with blue food coloring. Stir and set aside.

3. Add one cup of water to a measuring cup with a spout. Stir in one packet of drink mix.

HOW IT WORKS

Red, yellow, and blue cannot be made with other colors. They're called primary colors. By combining two primary colors, you can create secondary colors: orange, green, and purple. Experiment with making different colors. Can you make brown? Black?

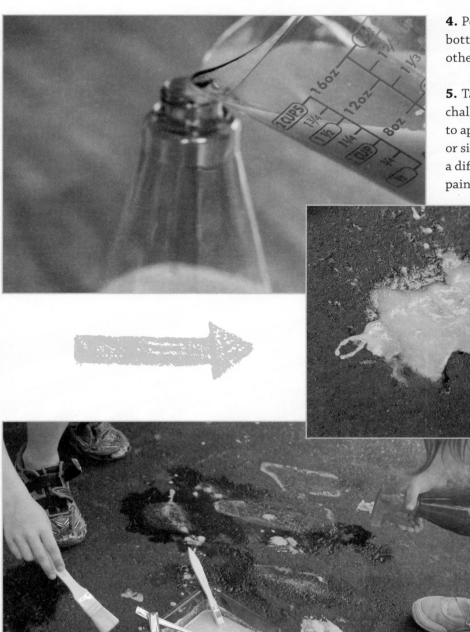

4. Pour the mixture into a spray bottle. Repeat twice more with the other drink mixes.

5. Take your spray bottles and bowls of chalk paint outside. Use a paintbrush to apply the chalk paint to a driveway or sidewalk, and then spray it with a different-colored spray. Watch the paints sizzle and change color.

6. Some drink mix colors are more vivid than others, so experiment and make adjustments if necessary. If you would like the color brighter, add some food coloring. If it's too bright for your taste, dilute it with some water.

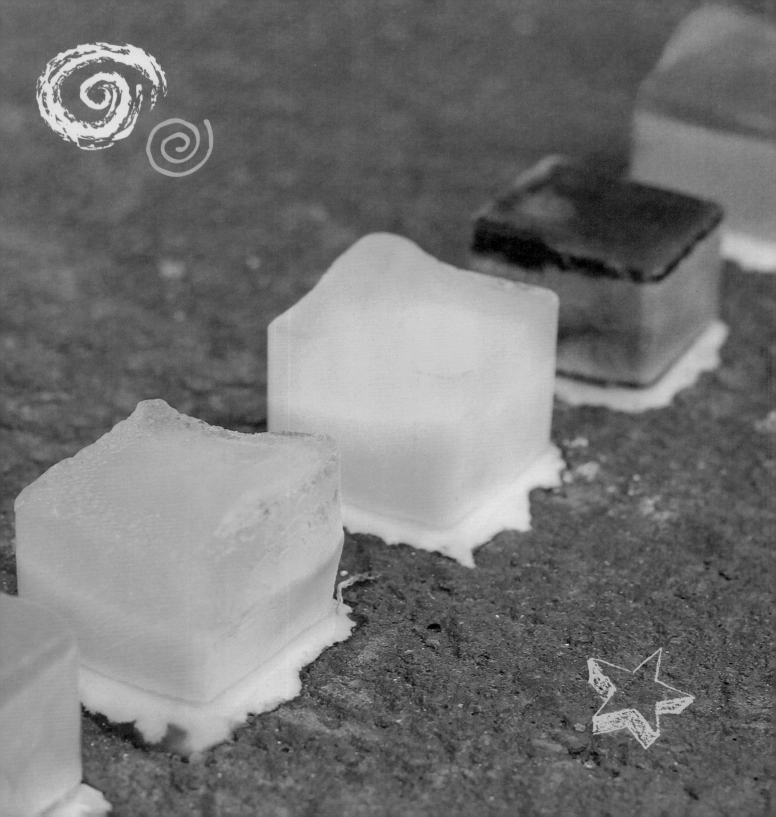

Ice Chalk

Nothing beats playing with ice chalk on a hot summer afternoon, because the warmer the weather, the better it works. Frozen chalk makes a great art, science, and sensory experience because it melts into puddles of oobleck. Get ready to get messy!

INGREDIENTS
- 1 cup warm water
- 1 cup cornstarch
- Food coloring or liquid watercolors
- Dishwashing detergent

SUPPLIES
- Bowls
- Spoons
- Measuring cup
- Ice cube tray or silicone molds

DIRECTIONS

1. Stir together the water and cornstarch. Keep mixing until the cornstarch is incorporated and the liquid is completely smooth.

2. Divide the mixture evenly into bowls, one for each color of ice chalk you'd like to make.

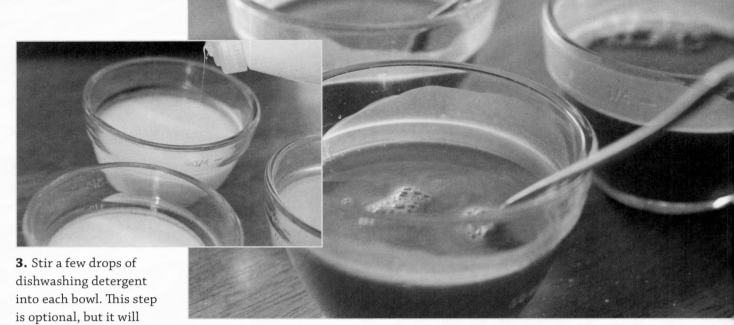

3. Stir a few drops of dishwashing detergent into each bowl. This step is optional, but it will make cleanup easier later.

4. Tint each batch using either food coloring or liquid watercolors. Use plenty of color because it will lighten as it freezes.

HOW IT WORKS

Oobleck is a substance made from cornstarch and water. It's called "non-Newtonian" because its viscosity, or flow, changes. Sometimes it acts like a liquid, and sometimes it acts like a solid. Oobleck got its name from a Dr. Seuss book called *Bartholomew and the Oobleck.*

5. Immediately pour the liquid into an ice cube tray, and place it in the freezer until the ice chalk is solid. The cornstarch may settle slightly while it's in the freezer, but it won't affect how the ice chalk works.

6. Once frozen, pop the ice chalk out of the trays and it's ready to use.

7. At first it may look like your ice chalk won't work for drawing on the pavement, but as it dries, the colors will become more vibrant. Have fun experimenting with the melting times of your ice chalk, and explore the ways you can mix the colors.

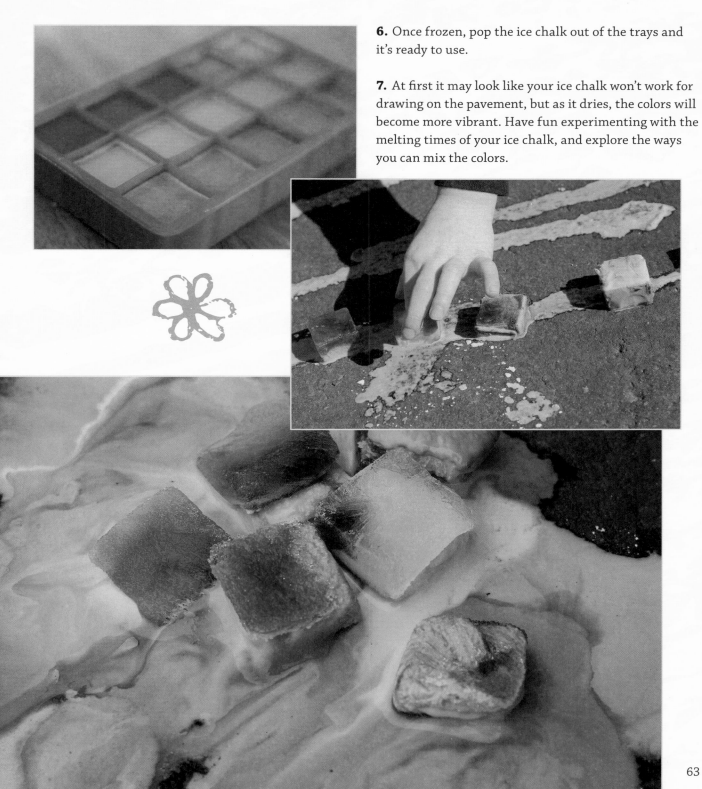

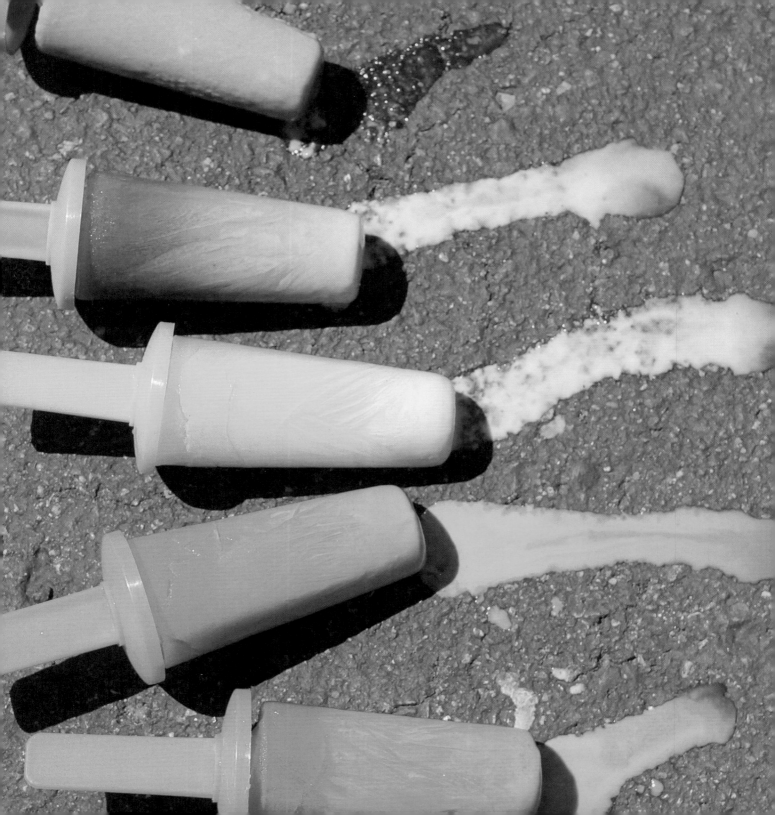

Scented Ice Pop Chalk

This fruity-smelling frozen chalk looks and smells good enough to eat, but don't let it fool you. This is one treat you don't want to eat! Luckily, you'll have just as much fun using it to make vibrantly colored chalk creations, and unlike most ice pops, they won't spoil your dinner. Keep a stash handy in the freezer for the perfect way to spend a hot summer afternoon.

INGREDIENTS
- 1 cup cornstarch
- 1 cup water
- 1 small packet unsweetened drink mix, any flavor

SUPPLIES
- Ice pop mold
- Mixing bowl
- Spoon

DIRECTIONS

1. Pour water into a mixing bowl. While stirring, slowly add the cornstarch and mix until completely dissolved. If clumps form at the bottom of the bowl, keep stirring until the mixture has a smooth consistency.

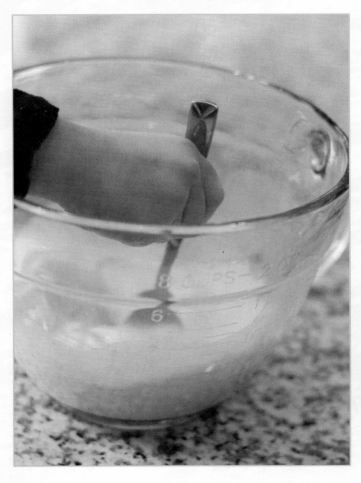

2. Add the packet of drink mix, and stir until blended.

3. Immediately fill each compartment of the ice pop mold, insert the sticks, and place the mold in the freezer for at least 3 hours. If the mixture sits too long at room temperature, the cornstarch will settle at the bottom of the bowl. Simply stir the mixture again to reincorporate it.

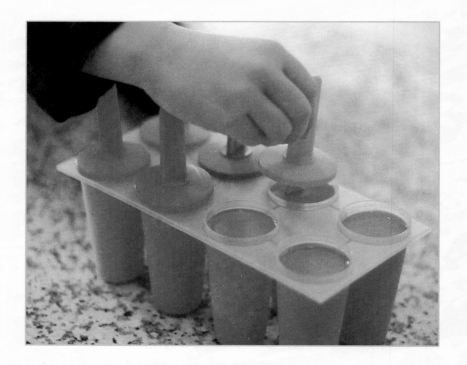

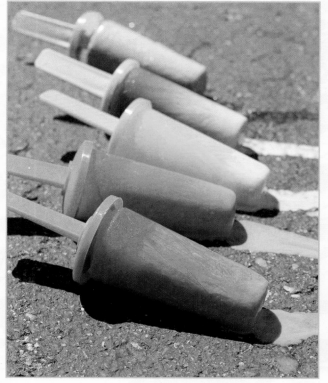

4. Once your ice pop chalk is completely frozen, remove it from the molds. If the chalk is sticking, let the pops sit for a few minutes or place the mold in a shallow bowl of lukewarm water until the chalk slides out easily.

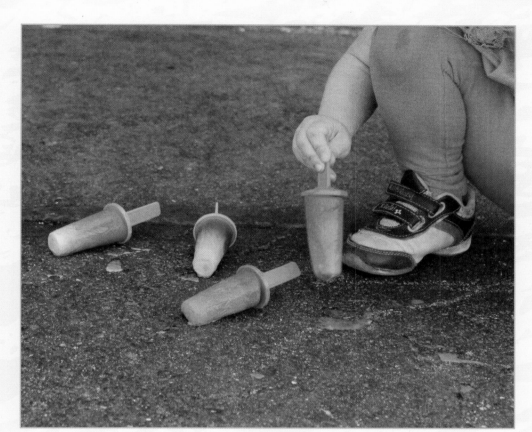

5. Your scented ice pop chalk is ready to enjoy. Take it outdoors and decorate your sidewalk and driveway with your colorful and aromatic chalk creations. As with regular ice chalk, the colors will become more vibrant as they dry.

HOW IT WORKS

As the ice pop chalk begins to melt, the scent from the drink mix becomes more noticeable. We smell things when they give off tiny, invisible molecules that reach our nose. As the chalk warms up, the molecules begin to move more quickly, and more of them escape into the air to reach our nose.

✳ Tip ✳

Try different flavors and colors for a rainbow of ice chalk pops. Or make your own combinations by mixing different scents together!

Frozen Fizzy Chalk

Here's a fun way to play with chalk and enact a science experiment at the same time. Frozen fizzy chalk is easy to make and is the perfect activity for a hot summer afternoon. Make as many colors and shapes as you like, and store them in the freezer for a sunny day.

INGREDIENTS
- ¼ cup baking soda
- ¼ cup cornstarch
- ½ cup water
- Washable liquid watercolor or food coloring
- Squirt of dish soap (optional, but makes cleanup easier)
- Vinegar

SUPPLIES
- Mixing bowls and spoons
- Measuring cups
- Ice cube tray or mold
- Freezer
- Spray bottle

DIRECTIONS
1. Pour baking soda into a bowl or cup. Measuring cups work well because the mixture can be poured more easily when it's finished. Add cornstarch, and pour in water. Stir to combine. Add dish soap, if using.

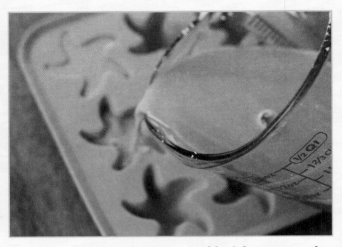

2. Tint the mixture with the color of your choice. The chalk will lighten as it freezes, so use plenty of color and stir well.

3. Pour into an ice cube tray or mold. If the cornstarch and baking soda have settled to the bottom, stir to reincorporate before pouring.

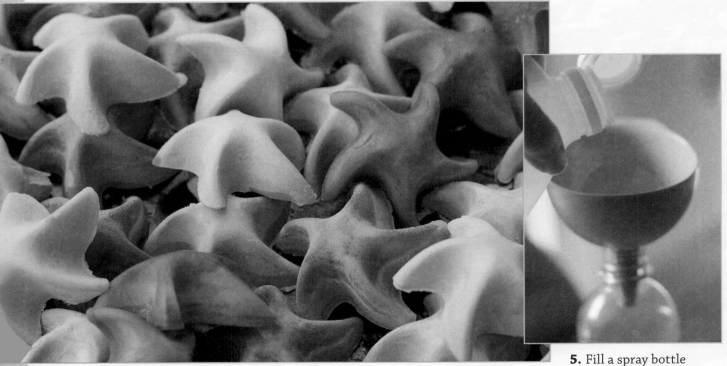

5. Fill a spray bottle with vinegar.

4. Place in the freezer until the chalk is frozen solid. Remove the frozen fizzy chalk from the molds. Because the chalk mixture expands slightly as it freezes, you might find that it will come out more easily after sitting at room temperature for a few minutes.

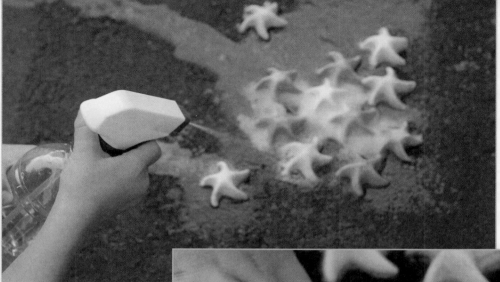

6. Place the frozen chalk pieces on a driveway or sidewalk. Spray with vinegar, and watch them fizz and bubble!

7. You can also use it to make colorful drawings just as you would regular chalk. The color will become more vibrant as it dries. As it begins to melt you can also mix the colors together.

HOW IT WORKS

The fizzing and bubbling of the frozen fizzy chalk is caused by the baking soda reacting with the vinegar. Vinegar contains an acid, while baking soda contains a base. Mixing the two together creates carbonic acid. This quickly breaks down into water and carbon dioxide—released as tiny, fizzing bubbles!

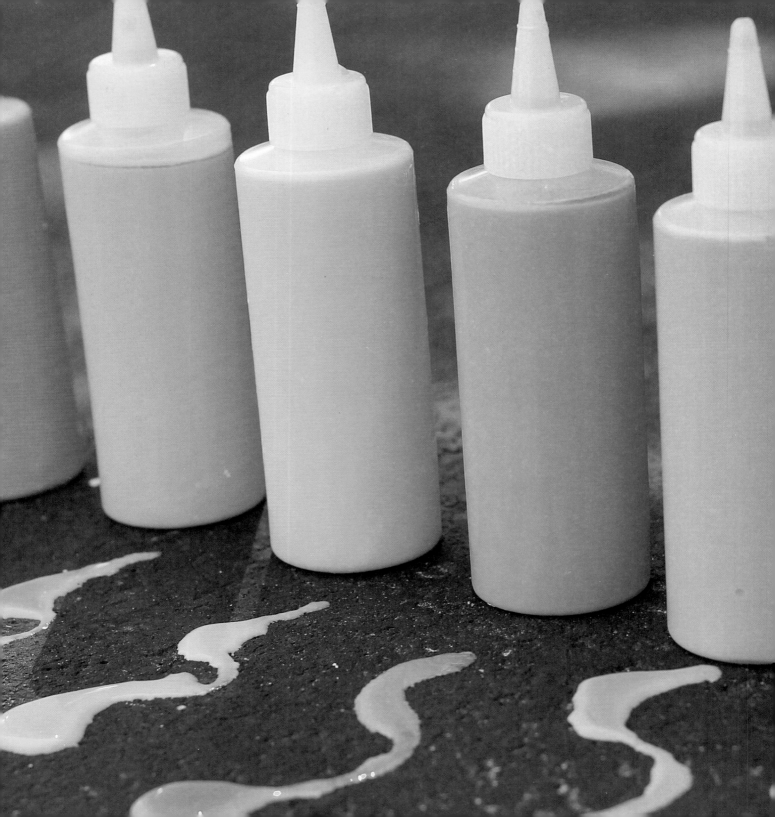

Sidewalk Chalk Paint

There are lots of variations of this basic sidewalk chalk paint recipe and many creative ways to use it. Customize it depending on your mood or whatever ingredients and supplies you have on hand. Substitute flour for cornstarch. Pour in some glitter. Try adding extract or essential oils to make it smell nice. Make it thick or thin. Adding a squirt of dishwashing liquid makes cleanup easier, but if you really want to ensure that the paint doesn't stain, choose a washable watercolor paint. Each batch makes one color of sidewalk chalk paint. It can easily be doubled or tripled.

INGREDIENTS
- ½ cup cornstarch
- ½ cup water
- Food coloring or washable liquid watercolor paint, any color
- Squirt of dishwashing liquid (optional)

SUPPLIES
- Mixing bowls and spoons
- Measuring cup
- Funnel
- Squirt bottle, one for each color

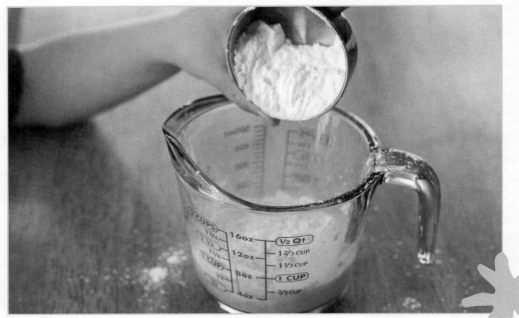

DIRECTIONS
1. Pour water into a mixing bowl. Add cornstarch and stir until combined.

2. The consistency of the paint can be adjusted by adding more cornstarch to make it thicker or adding more water to make it thinner.

3. Tint the mixture using food coloring or paint. The more you use, the more saturated the color will be. Add soap, if using, and stir to combine.

HOW IT WORKS

Different weather conditions will change the drying time of the sidewalk chalk paint. Heat will cause the paint to dry more quickly. If the temperature outside is below freezing, the water in the paint will turn to ice before it has a chance to dry. Factors like humidity and the thickness of the paint can also affect the drying time.

4. Use a funnel to transfer the mixture to a squirt bottle, and it's ready to take outdoors and use.

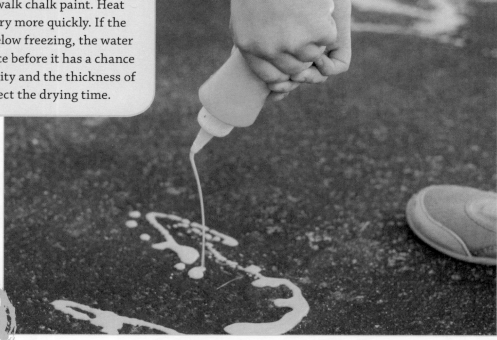

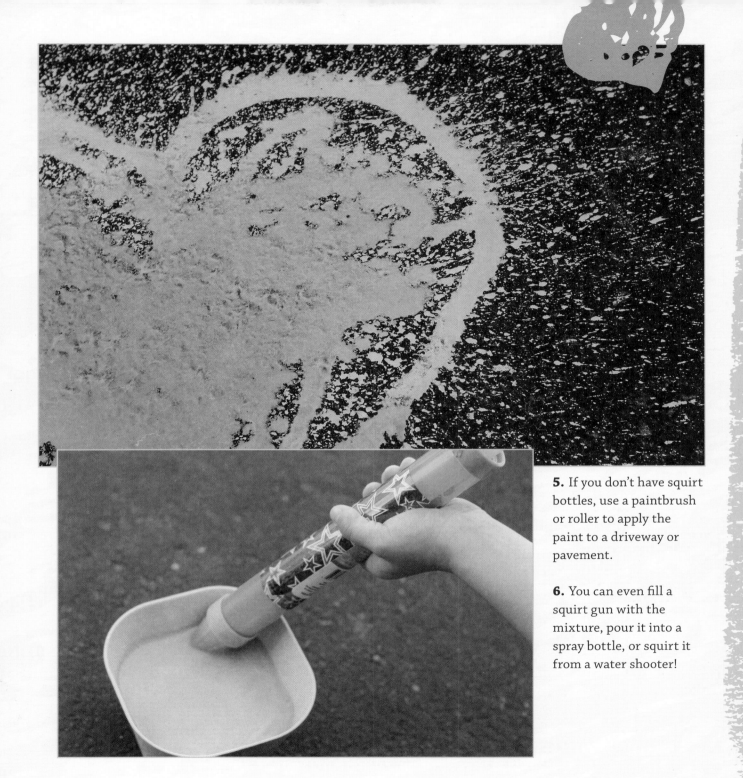

5. If you don't have squirt bottles, use a paintbrush or roller to apply the paint to a driveway or pavement.

6. You can even fill a squirt gun with the mixture, pour it into a spray bottle, or squirt it from a water shooter!

Chalk Whip Paint

This chalk whip paint is light and fluffy, similar to puffy paint, and it's made with just a few ingredients. As an added bonus, it smells wonderful when you use scented shaving foams (try raspberry)! Create as many paintings as you like with this paint; this recipe is so forgiving, you don't even have to measure the ingredients!

INGREDIENTS
- Sidewalk chalk in a variety of colors
- Shaving foam
- White school glue

SUPPLIES
- Quart freezer bags, one for each color of paint
- Hammer
- Old towel
- Small bowls, one for each color of paint
- Spoons for mixing
- Sturdy paper, such as card stock

DIRECTIONS
1. Place each stick of chalk into a separate bag. Squeeze out as much of the air as possible before sealing the bag.

2. Using a hammer, crush the chalk into a fine powder. Be sure to use a surface that won't be damaged by the hammer, and check often for holes in the bag. Placing an old towel under the bag will help catch any accidental leaks. Repeat for each color of chalk.

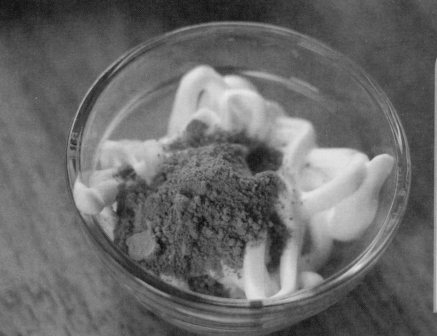

HOW IT WORKS

Is shaving foam a solid, a liquid, or a gas? Actually, it's all three! It's made from soap (solid) and water (liquid) in which tiny air bubbles (gas) are trapped. Jello, whipped cream, and hair gel are other examples of substances that aren't easily identified as a single state of matter. Scientists call these substances *colloids*.

3. Fill a small bowl with shaving foam. Add a spoonful or two of glue. Add as much or as little chalk powder to the mixture as you'd like. The more powder you add, the more saturated the color will be.

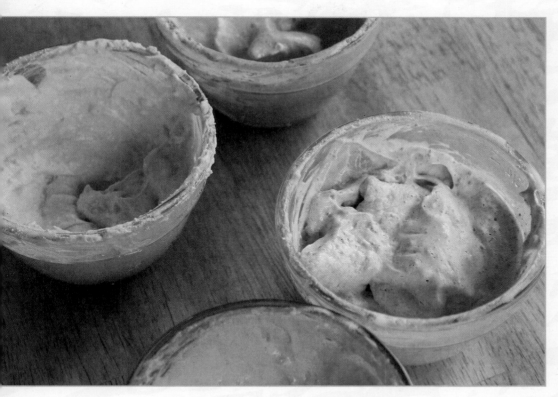

4. Stir gently to combine. As you mix, the shaving foam will lose some of its volume. Don't overmix, and the paint will stay puffy. Repeat for each paint color.

5. Use your chalk whip paint right away. Sturdy paper will stand up better to this paint. Chalk whip paint gives a three-dimensional effect to your art. Allow finished paintings to dry completely on a flat surface before handling or hanging them.

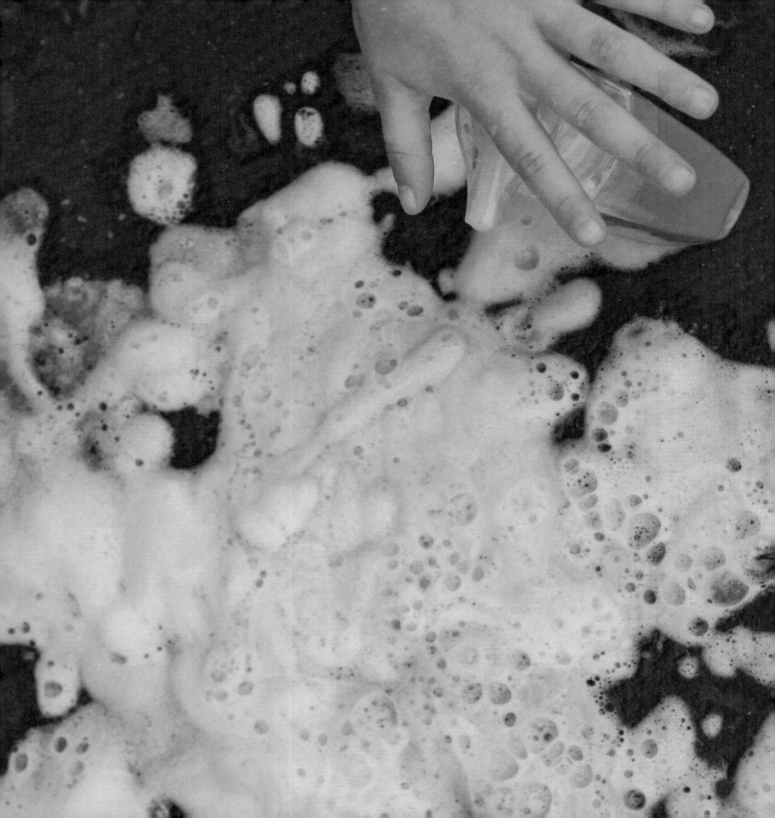

Foaming Chalk

Foaming chalk is a fun twist on sidewalk chalk paint. With just a few ingredients and some empty soap containers, you can create mounds of colorful, bubbly chalk. It's also a great way to recycle hand soap containers. Be sure the soap pump you're using is designed for foaming hand soap, or the chalk mixture won't foam properly.

INGREDIENTS
- 1 cup warm water
- ¼ cup cornstarch
- Food coloring
- 1 tablespoon liquid hand soap

SUPPLIES
- Empty foaming hand soap containers, one for each color
- Mixing bowl and spoon
- Measuring cups

DIRECTIONS
1. Pour warm water into a bowl. Add cornstarch and stir until smooth.

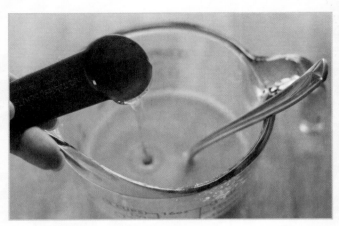

2. Tint the mixture with food coloring. Add hand soap, and stir gently to avoid making too many bubbles.

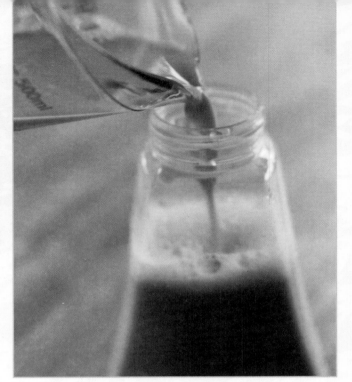

3. Pour the mixture into an empty hand soap container.

4. Use the pump to dispense the foaming chalk just as you would soap. Foaming chalk can be made in many different colors. Try neon food coloring or mixing your own shades.

HOW IT WORKS

The earliest soap was made from ashes, water, and oil. Liquid soap wasn't manufactured until much later, and even more recently, foaming soap, a form of liquid soap, was developed. A foaming soap dispenser has a chamber that mixes the soap with air to form lots of frothy bubbles, which is why it works so well for making foaming chalk.

5. As you use the foaming chalk, the cornstarch may settle to the bottom. Give it a gentle shake or turn the container over a few times to reincorporate the cornstarch.

6. It can be used indoors or outdoors (but be warned, it can get messy!). It will lose volume as it dries, but the imprints from the bubbles will be visible in the texture of the dried chalk.

83

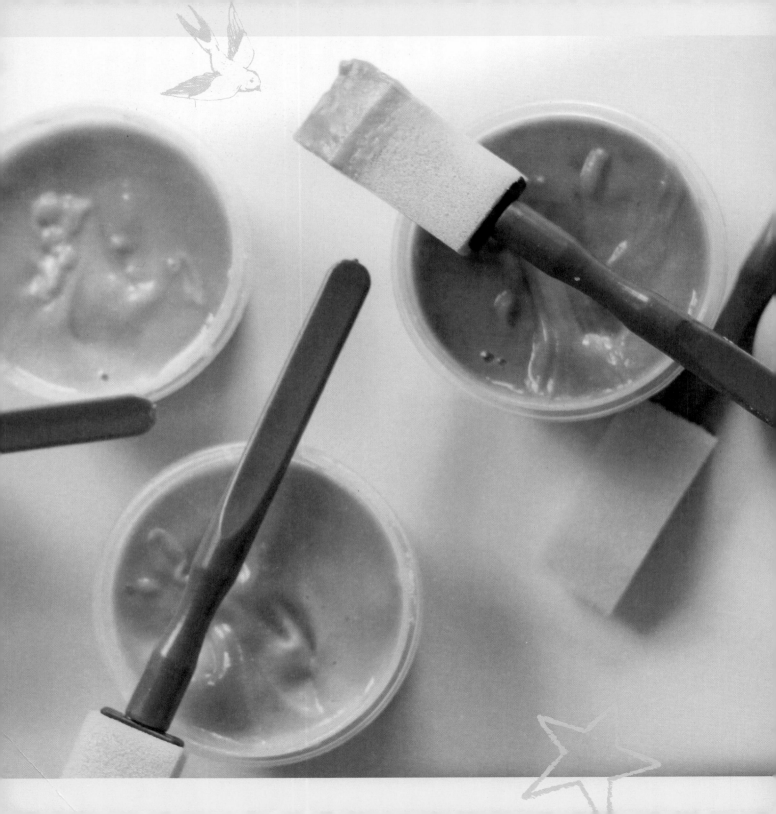

Chalky Bath Paint

Although this bath paint contains no chalk, it's made with baking soda so it has the look and feel of liquid chalk. This is especially true when the bath paint is allowed to dry on the tub surface. Best of all, it's made with ingredients that are safe for skin and tub surfaces and will leave your bathtub cleaner than it was before! It wipes off easily when wet or dry. Each batch makes one color, so make as many or as few colors as you like.

INGREDIENTS
- ¼ cup baking soda
- 1 tablespoon water
- 1 tablespoon clear liquid soap
- 3-4 drops liquid food coloring

SUPPLIES
- Small container with lid
- Mixing spoon
- Measuring cup and spoon

DIRECTIONS
1. Combine the baking soda and water in the container. You'll have a thick paste.

2. Pour in the soap and stir. Depending on the soap you use, you may need to adjust the consistency. Add more water if the paint is too thick; add more baking soda if it's too thin.

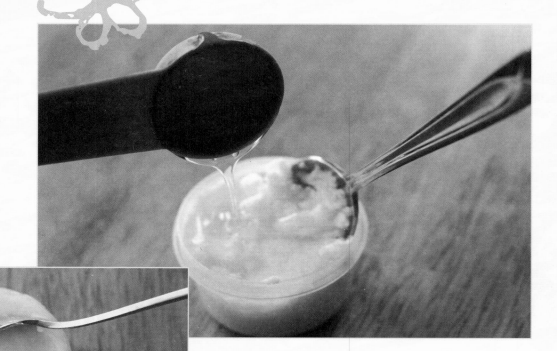

3. Mix in the food coloring.

HOW IT WORKS

Soap works because it's a *surfactant*. One end of a surfactant molecule attracts water (hydrophilic) and the other is attracted to dirt, grime, and oil (hydrophobic). Hydrophobic ends attach to the oil and hydrophilic ends stick to the water. This causes the oil to be suspended in the water so it can be easily washed away.

4. Use sponge brushes, art brushes, or your fingers to apply to the tub or shower surface.

5. Keep tightly closed when not in use and your chalky bath paints should last for several bath times, though the paint may need to be mixed again.

6. Get messy while getting clean—mix colors, create a huge work of art, make bubbles, and have fun. Just be careful—the soap can make the tub slippery!

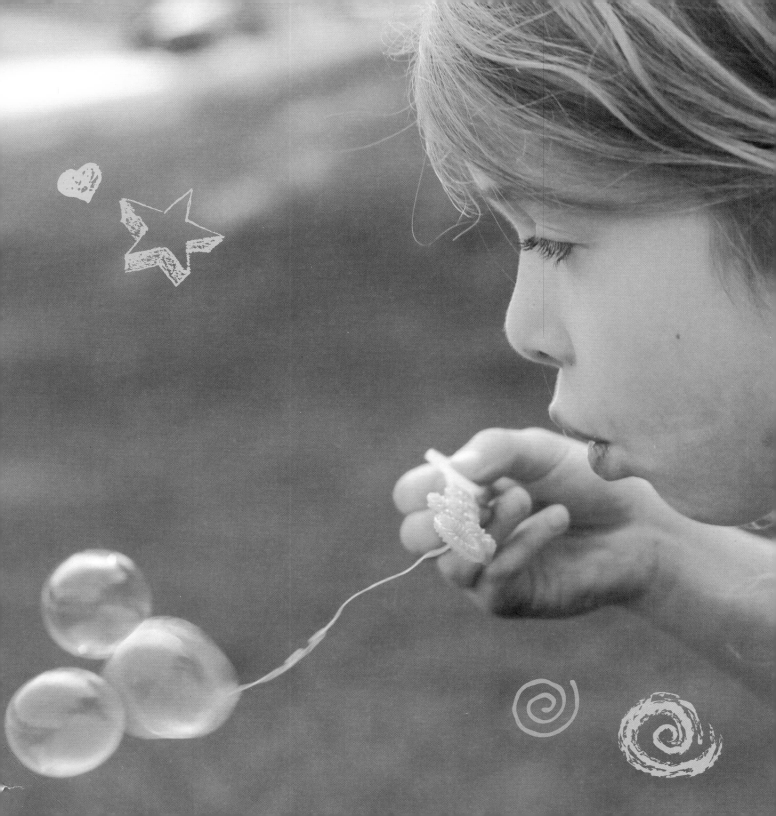

Chalk Bubbles

Combine two summer classics, chalk and bubbles, with this one simple recipe. Chalk bubbles may not look much different while they're floating through the air, but when they land on the sidewalk they leave chalk paint behind! The designs made from the popping bubbles become even more visible once the bubble solution has had a chance to dry. For an even quicker version of this recipe, you can combine the cornstarch and food coloring with ½ cup of store-bought bubble solution.

INGREDIENTS
- ½ cup water
- ½ tablespoon dishwashing liquid (the blue kind works best)
- 3 tablespoons cornstarch
- 10-20 drops food coloring

SUPPLIES
- Measuring cups and spoons
- Mixing spoon
- Container for chalk bubble solution
- Bubble wand

DIRECTIONS
1. Pour water into a container. Add cornstarch and stir until dissolved.

☀ TIP ☀
There's a lot of food coloring in this recipe, so be extra careful about staining. Wear play clothes and test a small area of the surface you'll be playing on to be sure the bubble solution will wash off.

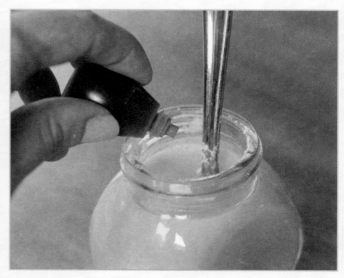

2. Gently stir in dishwashing liquid.

3. Tint the mixture with food coloring and stir to combine.

4. Use immediately as you would any other bubble solution, but watch what happens as the bubbles land. They'll leave behind chalk paint, which will dry and show exactly where the bubble popped!

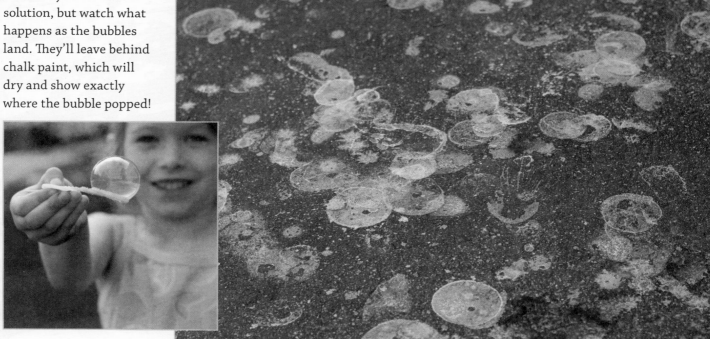

5. The cornstarch will settle to the bottom of the bubble solution, so keep stirring the mixture gently with your bubble wand as you use it.

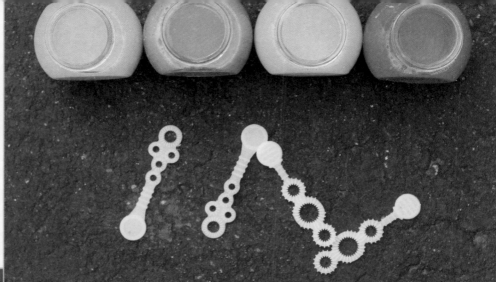

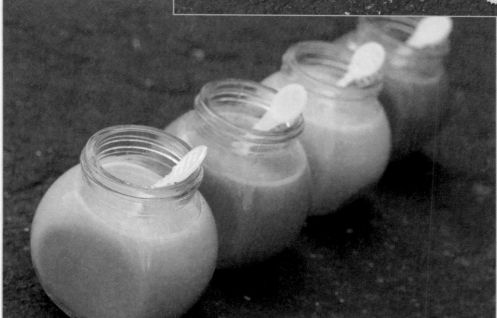

6. Try making different colored chalk bubbles or decorating just one area of pavement. For another twist, try catching the chalk bubbles on a piece of paper to see the designs. If you store the chalk bubbles they will need to be gently mixed before they can be used again.

HOW IT WORKS

When they're floating freely through the air, bubbles are round. This is because the tension in the skin of the bubble shrinks to the smallest space possible, which is a sphere. However, there are times when bubbles are not round. Wind can stretch a bubble into different shapes, or there may be many bubbles piled on top of each other, causing some of them to be squashed.

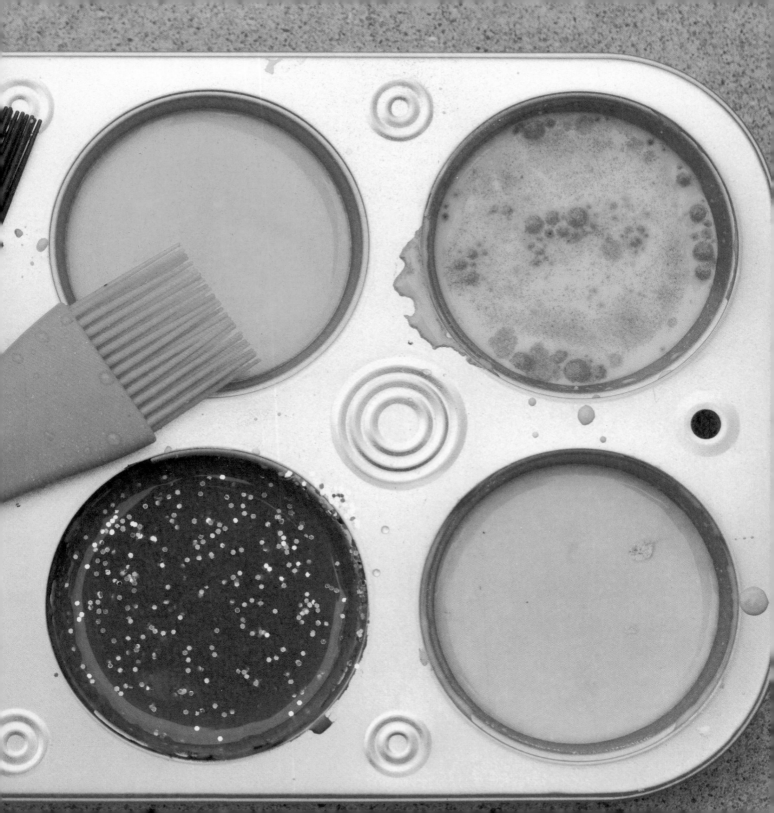

Gooey Sensory Chalk

Thicker than regular chalk paint, gooey chalk offers the perfect opportunity for sensory play because it can be used to engage multiple senses at the same time, including touch, smell, and sight. Adding sand, glitter, and scent increases the sensory experience even more, and makes this recipe very versatile.

INGREDIENTS
- ¼ cup water
- 2 tablespoons cornstarch
- 1 small packet unsweetened drink mix, any flavor
- Additions, such as glitter or play sand (optional)

SUPPLIES
- Measuring cups and spoons
- Mixing bowl and spoon
- Muffin tin (optional)
- Silicone pastry brushes (optional)

DIRECTIONS
1. Add water to a bowl. Stir in cornstarch and mix until smooth. You can adjust the consistency by adding more cornstarch to make it thicker or more water to make it thinner.

HOW IT WORKS

Many sources claim we have five senses (sight, smell, sound, taste, and touch), but others say we have many more. These additional senses include thirst and hunger, body awareness, pain, and even detecting the passage of time.

2. Add the drink mix a little at a time and stir. Some colors may stain concrete, so be sure to test an inconspicuous area first and add only enough drink mix to get the desired color and smell.

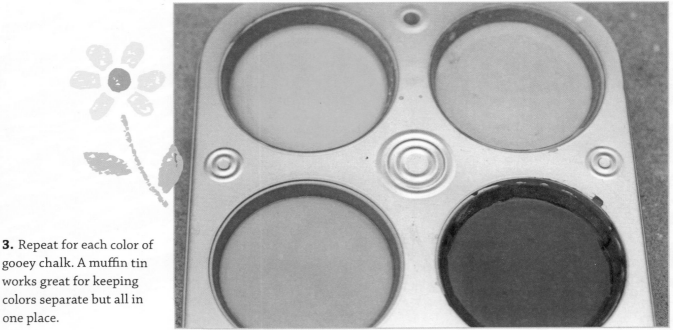

3. Repeat for each color of gooey chalk. A muffin tin works great for keeping colors separate but all in one place.

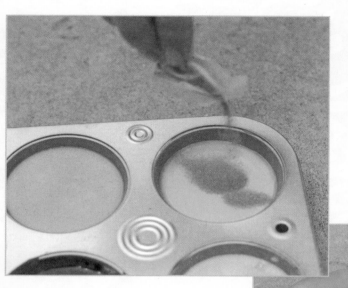

4. Get creative and stir in anything that increases the sensory experience. Play sand, glitter, dried rice or beans, and even ground chalk are good choices.

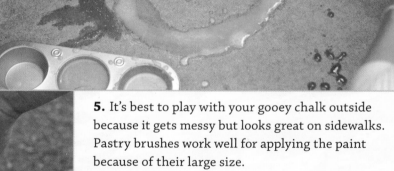

5. It's best to play with your gooey chalk outside because it gets messy but looks great on sidewalks. Pastry brushes work well for applying the paint because of their large size.

6. Your hands work even better! Experiment with mixing the colors and scents of the gooey chalk, and have fun making your own combinations.

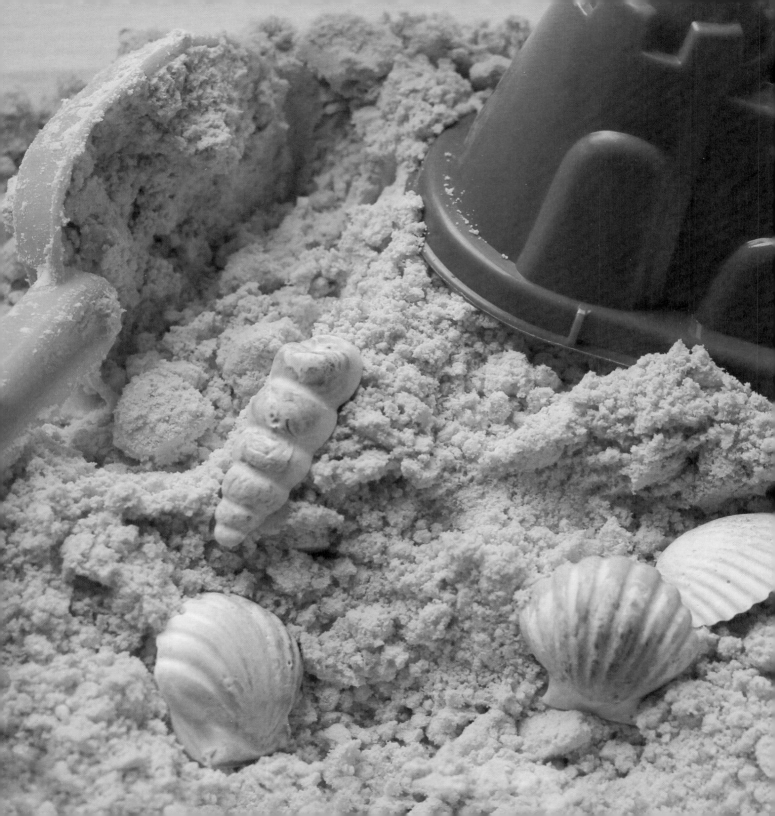

Chalk Dough

Chalk dough gets its vibrant color from sidewalk chalk and has only three ingredients. This sensory dough feels soft and silky and can be molded into different shapes. Store-bought or homemade chalk works equally well for making the dough.

INGREDIENTS
- 2-4 pieces colored sidewalk chalk
- 8 cups all-purpose flour
- 1 cup baby oil

SUPPLIES
- Quart freezer bag
- Towel
- Hammer (or mallet)
- Measuring cup
- Mixing spoon
- Large mixing bowl
- Potato masher (optional)

DIRECTIONS
1. Place the chalk into the freezer bag and seal. The more pieces of chalk you use, the darker the finished dough will be.

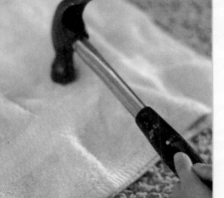

2. Wrap the bag in a towel, and pound it with a hammer until the chalk is crushed into a fine powder. Check periodically to be sure the bag hasn't broken.

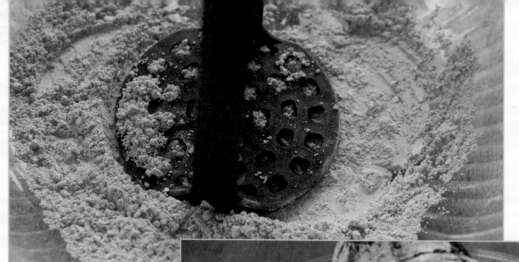

3. Dump the chalk powder into a large bowl. You can use a potato masher to break up any chalk that hasn't been crushed.

4. Add the flour, and stir to combine.

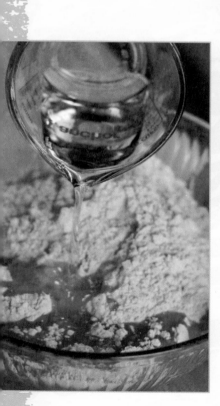

5. Add the oil. Because it is colorless, baby oil works well, but you can also substitute vegetable oil.

HOW IT WORKS

Chalk is used to color the dough in this recipe because water-based food coloring or paint won't work. Water and oil don't mix because their molecular structure is different. Water is made of *polar* molecules (one end is positively charged and the other is negatively charged), while oil is made of *nonpolar* molecules.

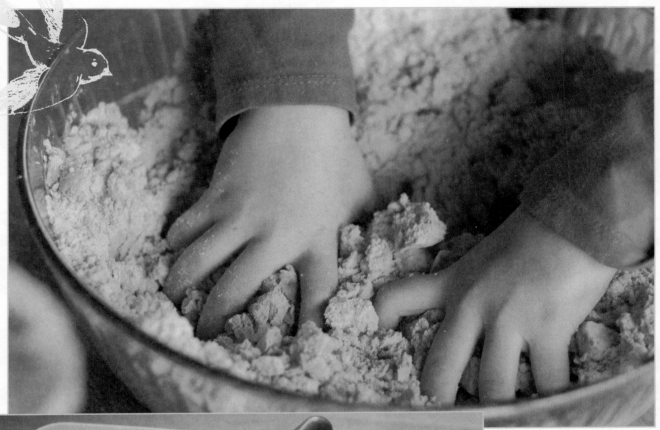

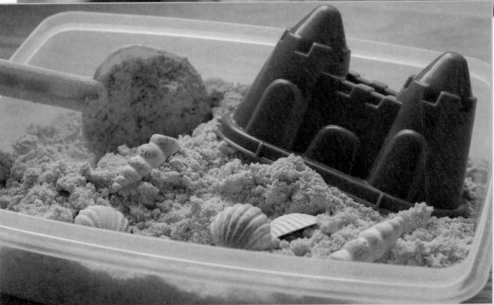

6. Keep stirring until the oil is incorporated into the flour and chalk. You may need to use your hands or the potato masher to thoroughly mix it.

7. When the chalk dough is finished it will look and feel like damp sand. Head outside to play because it can get very messy! Try making several colors and mixing them together for rainbow chalk dough.

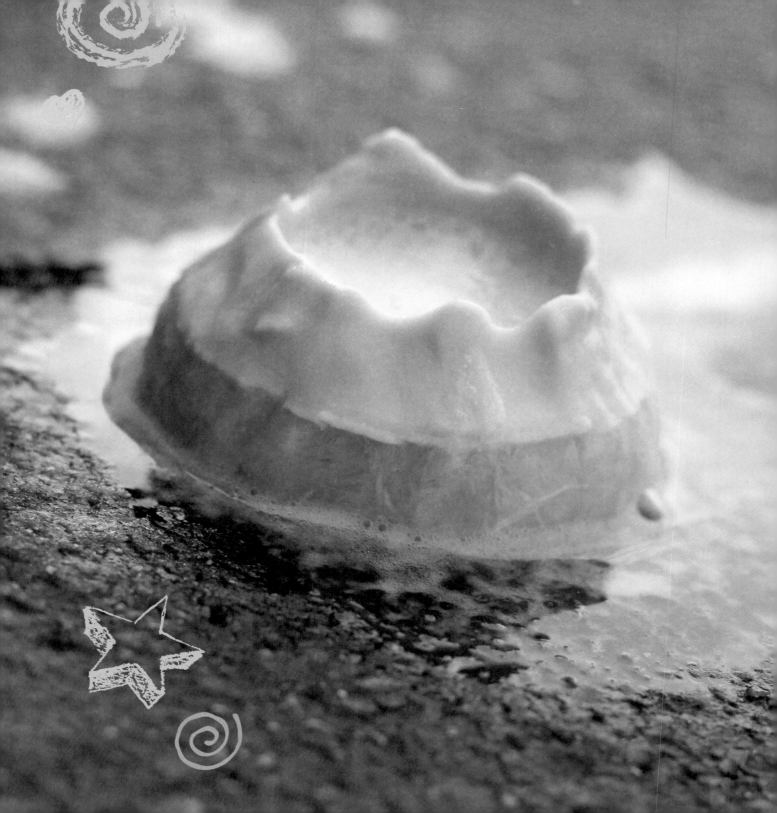

Ice Chalk Volcanoes

Turn fizzing ice chalk into an erupting frozen volcano with this fun twist on a classic science experiment. A few ingredients from the pantry are all you need to create a volcano in any size or color you can dream up!

INGREDIENTS
- A batch of Frozen Fizzy Chalk, any color
- Vinegar

SUPPLIES
- Bowls
- Plastic wrap
- A ball that sinks (such as a golf ball)
- Turkey baster

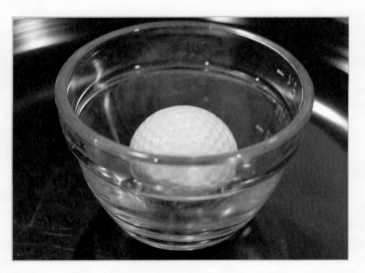

DIRECTIONS

1. Place the ball in the bottom of the bowl.

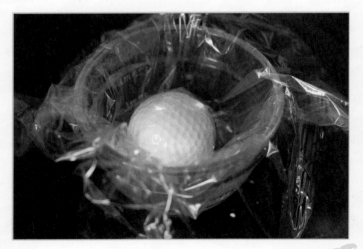

2. Line the bowl with a layer of plastic wrap, tucking it in around the outer edges of the ball. The ball should be underneath the plastic wrap, and the plastic wrap should overlap the sides of the bowl.

3. Prepare the recipe for Frozen Fizzy Chalk, and fill the volcano molds you've just made. Be sure to pour enough of the mixture to completely cover the ball, or you'll have a hole in the middle of your chalk volcano.

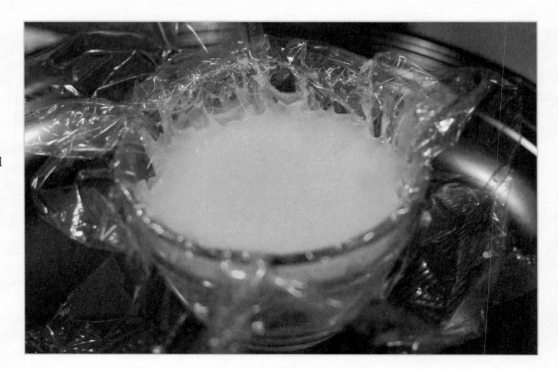

4. Place the volcanoes in the freezer until they're solid, at least four hours. Remove the volcanoes from the freezer and allow them to sit on the counter until they are slightly melted. This will make it easier to remove the ball in the center.

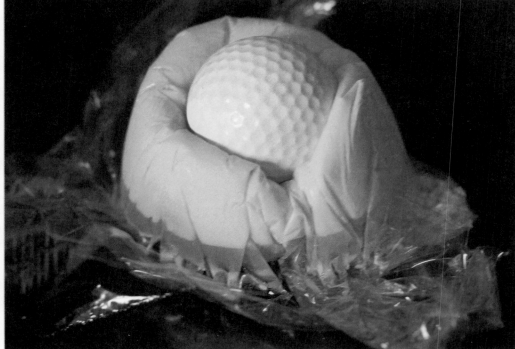

5. Remove the ball, and peel away the plastic wrap. It might be necessary to carefully pry out the ball or let the volcano thaw for a while longer to more easily remove the ball. It's not important to remove every bit of plastic wrap.

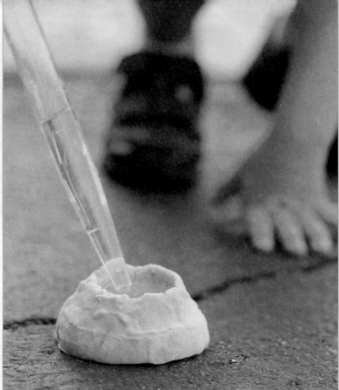

6. Invert your chalk volcano, and it's ready to take outside. Use a turkey baster to squirt vinegar into the well of the volcano, and watch it erupt! If you're doing this activity indoors, be sure to place your volcano in something that's big enough to catch all the bubbles!

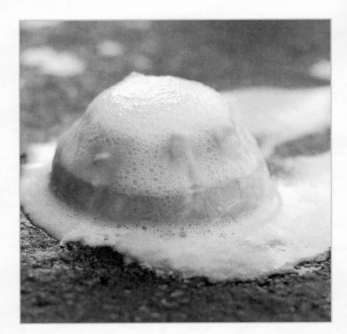

7. The chalk volcanoes can be used over and over again until they dissolve or a hole develops in the middle. Experiment to see how many eruptions you can get from a single volcano!

HOW IT WORKS

The reaction between the baking soda and vinegar in the chalk volcano mimics the eruption of a real volcano, but real volcanoes can send ash more than 2 miles into the air! They spew hot magma, ash, and gas, with eruptions sometimes lasting for years. It would take a lot of baking soda and vinegar to match the strength of a real volcano!

Chalk Rockets

Homemade rockets are a classic science activity, and this chalk version is even more fun. A batch of chalk paint made with vinegar instead of water, baking soda, and film canisters are all you need to achieve blastoff and create colorful chalk art at the same time. Clear or white film canisters work best. They can be purchased inexpensively online and can be used over and over again. Be aware, this is an activity that requires adult supervision.

INGREDIENTS
- Vinegar
- Cornstarch
- Food coloring or washable watercolor paint
- Baking soda

SUPPLIES
- Safety goggles
- Film canisters with caps
- Measuring spoons
- Mixing spoon
- Cap from a water bottle, small enough to fit inside the film canister

DIRECTIONS

1. Find an outdoor space with plenty of room. Pour one tablespoon of vinegar into a film canister.

2. Add ½ tablespoon of cornstarch.

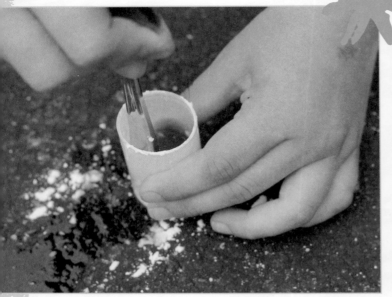

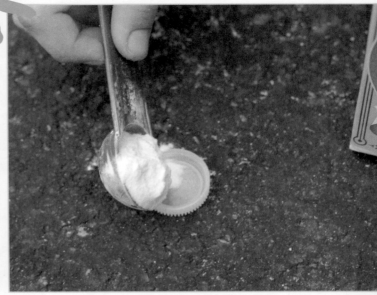

3. Add a drop or two of coloring. Stir with the handle of a spoon.

4. Fill the water bottle cap with baking soda.

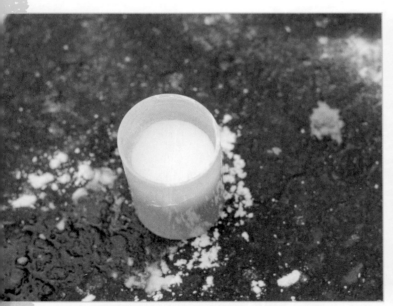

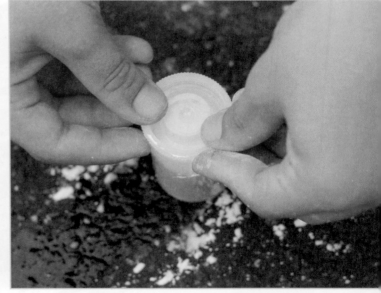

5. Place the filled water bottle cap inside the film canister so that it floats on top of the vinegar. Be careful not to spill the baking soda into the vinegar yet.

6. Put on the safety goggles, and carefully snap the film canister cap onto the film canister.

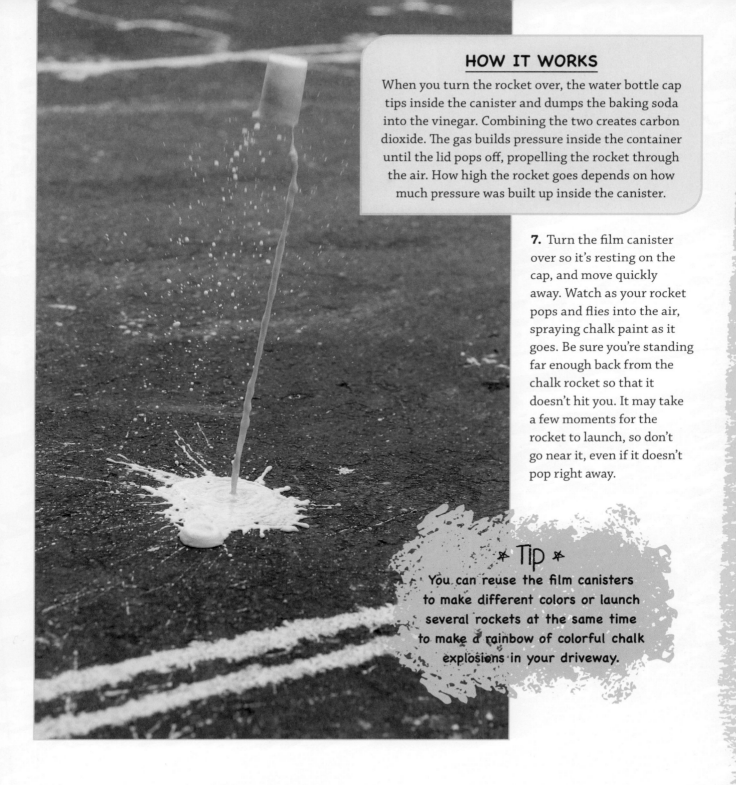

HOW IT WORKS

When you turn the rocket over, the water bottle cap tips inside the canister and dumps the baking soda into the vinegar. Combining the two creates carbon dioxide. The gas builds pressure inside the container until the lid pops off, propelling the rocket through the air. How high the rocket goes depends on how much pressure was built up inside the canister.

7. Turn the film canister over so it's resting on the cap, and move quickly away. Watch as your rocket pops and flies into the air, spraying chalk paint as it goes. Be sure you're standing far enough back from the chalk rocket so that it doesn't hit you. It may take a few moments for the rocket to launch, so don't go near it, even if it doesn't pop right away.

✳ TIP ✳

You can reuse the film canisters to make different colors or launch several rockets at the same time to make a rainbow of colorful chalk explosions in your driveway.

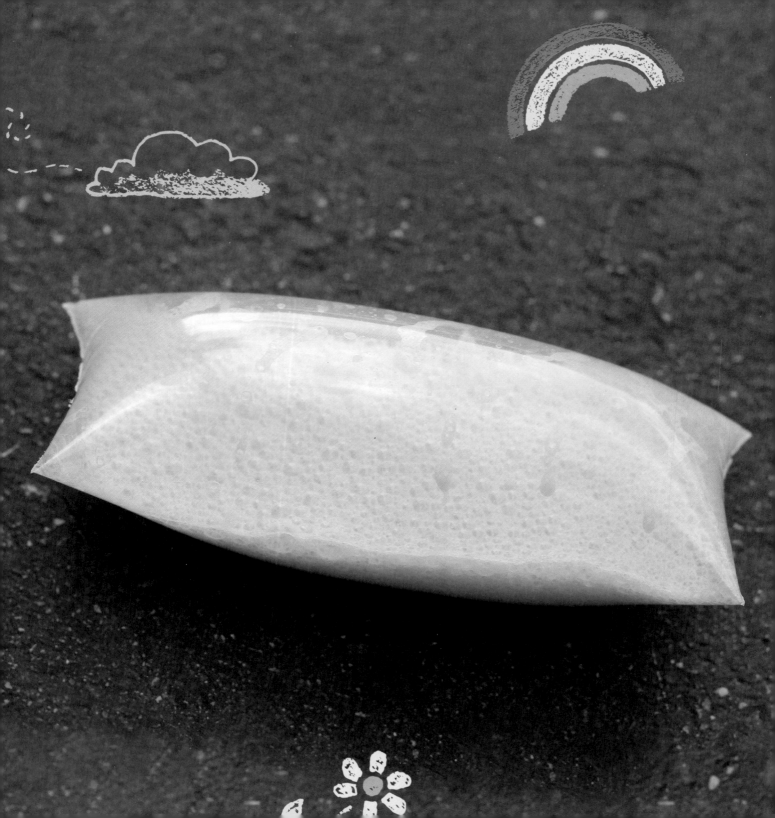

Exploding Stomp Chalk

Chalk doesn't get messier than this! Stomp on airtight bags full of fizzy chalk paint to make them explode. Exploding stomp chalk is quick to put together and appeals to just about everybody. Warning: This is an activity that should be done outdoors wearing play clothes!

INGREDIENTS
- Sidewalk chalk paint, ½ cup for each bag (see page 72)
- Effervescent antacid tablets (such as Alka-Seltzer®), 1 for each bag

SUPPLIES
- Snack-size bags with zipper closure
- Measuring cups
- Safety goggles

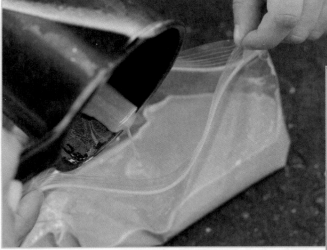

DIRECTIONS
1. Fill each snack bag with ½ cup of sidewalk chalk paint.

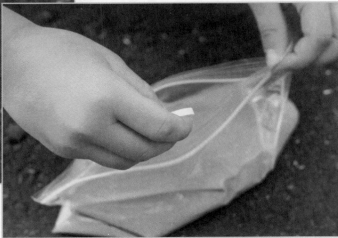

2. Add one antacid tablet to each bag.

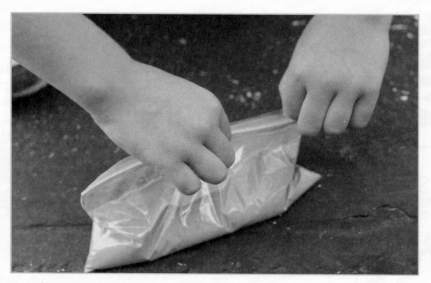

3. Seal the bag tightly so it won't leak. Don't squeeze the air out of the bag before sealing.

> ✳ **TIP** ✳
> Exploding chalk bags must be made immediately before use because they don't store well (for obvious reasons!). Be sure to clean the area when you're finished and dispose of the used snack bags properly.

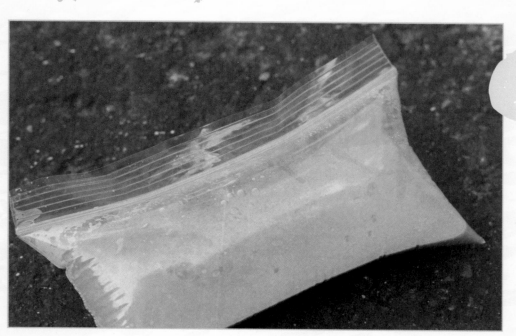

4. Watch as the bag begins to swell. It will continue to grow larger until it looks very full. Put on the safety goggles.

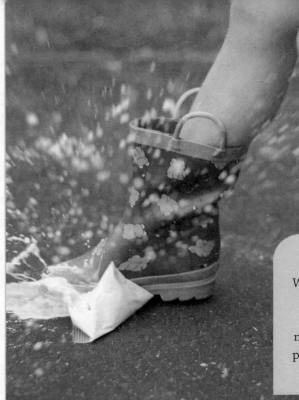

5. Once the bag seems like it's about to pop, use your foot to stomp on it and watch it explode! The longer you wait to stomp on the bag, the better the explosion you'll get. (Just don't wait so long that the bag explodes on its own!)

HOW IT WORKS

When the effervescent tablet is submerged in the liquid, bubbles of carbon dioxide gas are released. The longer the tablet bubbles, the more gas fills the bag, and the more the bag expands. When you stomp on the bag, the pressure is released through the holes created in the bag and the chalk paint goes flying!

6. If you want to make several bags of exploding stomp chalk in different colors, make a big batch of white chalk paint (just leave out the color). Once you've divided the chalk paint into the snack bags, add a drop or two of paint or food coloring to each bag. Seal the bag and give it a shake to mix.

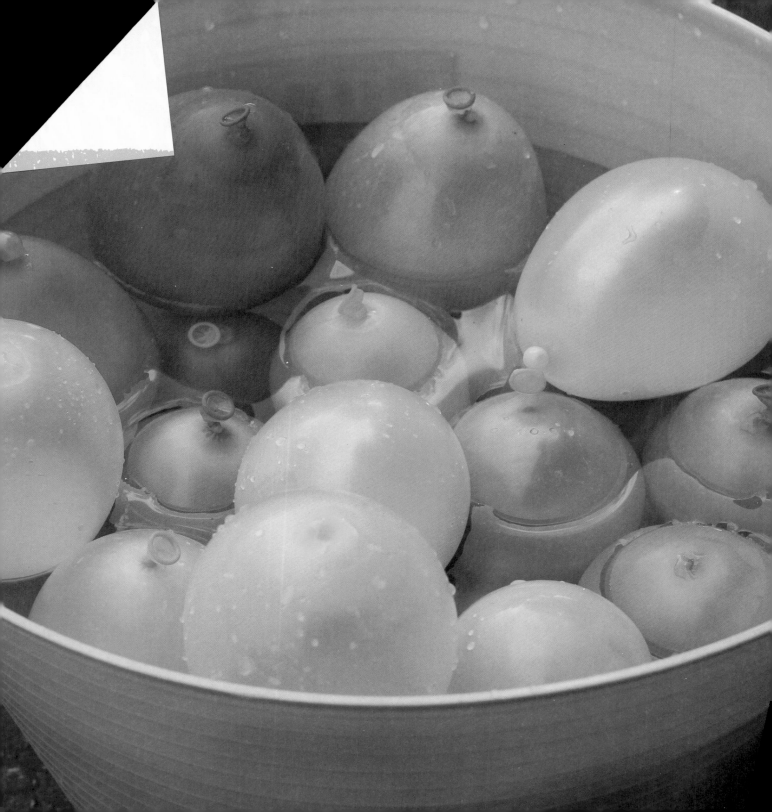

Chalk Bombs

Filled with sidewalk chalk paint, chalk bombs are a fun twist on regular water balloons. Not only are they fun to throw, they also leave a colorful splash behind. Store the extras in the freezer to make frozen marbles (page 116).

INGREDIENTS
- Water balloons
- Batch of sidewalk chalk paint, any color (see page 72)

SUPPLIES
- Water-balloon pump and filler, large pump bottle, or water shooter
- Sidewalk chalk (optional)

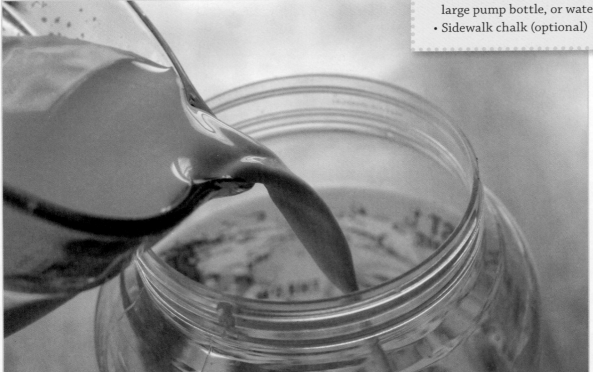

DIRECTIONS

1. Make a batch of sidewalk chalk paint in the color of your choice. Pour the mixture into the water-balloon pump.

2. Fill the water balloons with the water-balloon pump and tie.

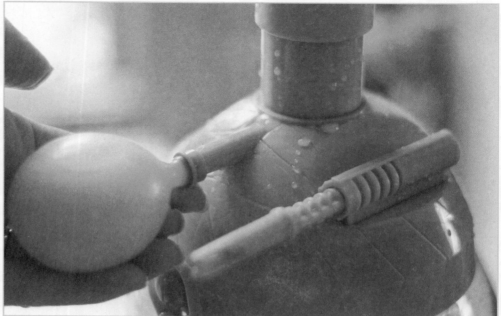

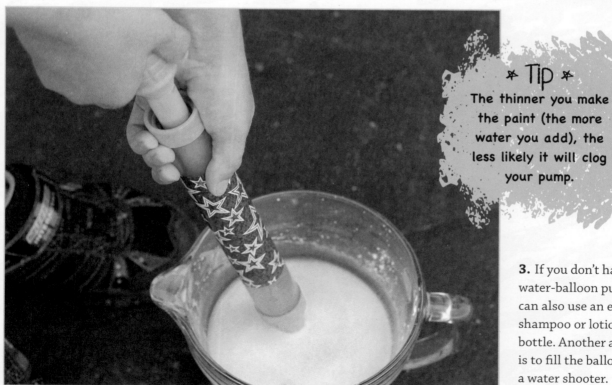

✷ Tip ✷
The thinner you make the paint (the more water you add), the less likely it will clog your pump.

3. If you don't have a water-balloon pump, you can also use an empty shampoo or lotion pump bottle. Another alternative is to fill the balloons with a water shooter.

4. Use them like regular water balloons, but watch as the paint makes colorful designs on the sidewalk or driveway as they burst open. Don't forget to save a few to make frozen marbles (page 116)!

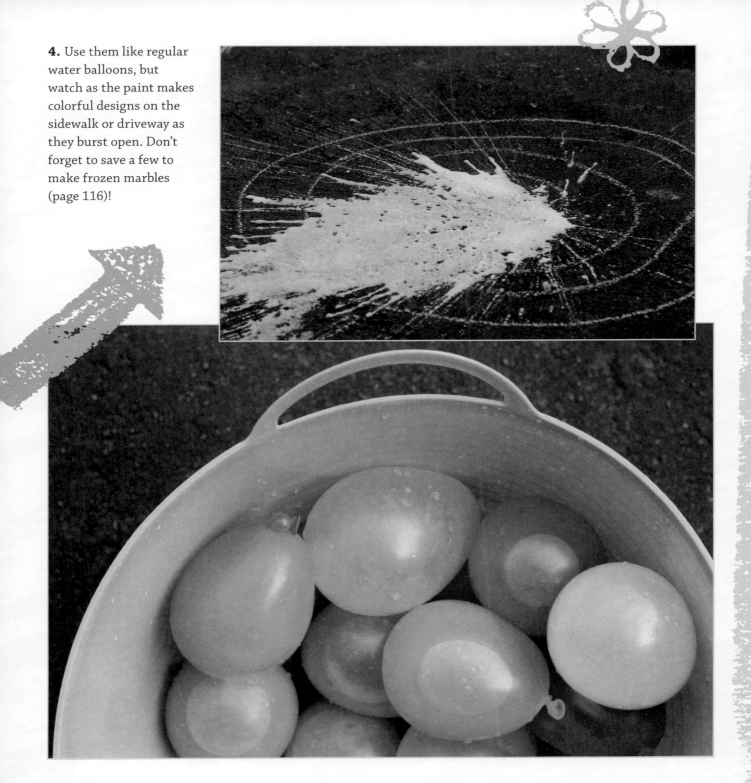

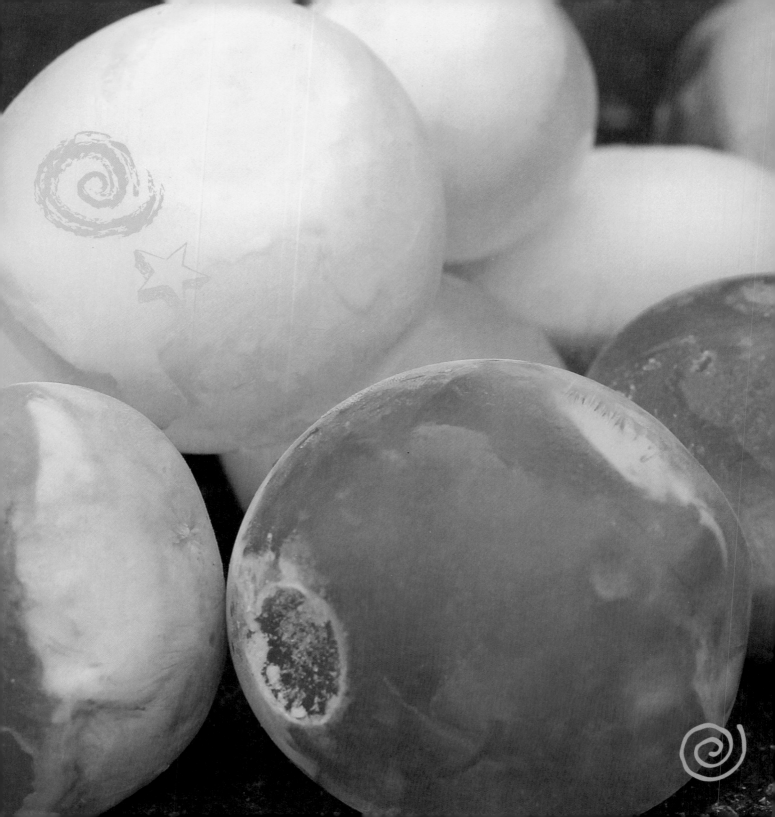

Frozen Marbles

Got some extra chalk balloons? Put 'em in the freezer and make a batch of frozen marbles. Draw targets on the driveway and play a quick game of marbles, or simply let them melt on the pavement in the hot sun, and watch how their colors mix and blend. The opportunities are endless!

INGREDIENTS
- Water balloons
- Batch of sidewalk chalk paint, any color (see page 72)

SUPPLIES
- Water-balloon pump and filler, large pump bottle, or water shooter
- Sidewalk chalk (optional)

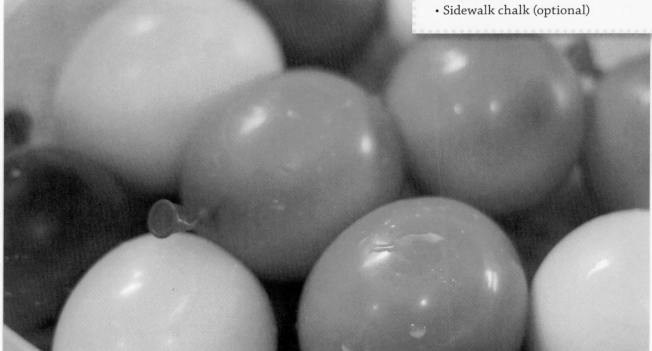

DIRECTIONS
1. Follow steps 1 through 3 from Chalk Bombs (page 112), and then place the filled balloons in the freezer until solid.

2. Once frozen, cut the tie off each balloon. Peel off the balloon and discard.

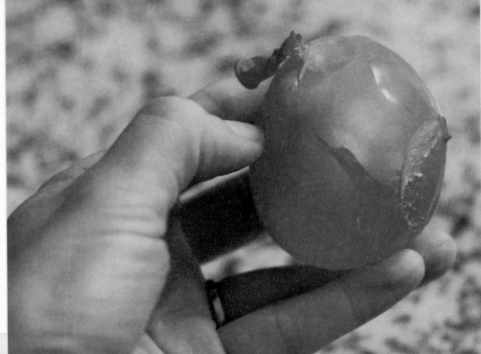

✳

3. It's likely that some cornstarch has settled to the bottom and your marbles will not be perfectly round. If you'd like them smoother, run them under water until they're the right shape.

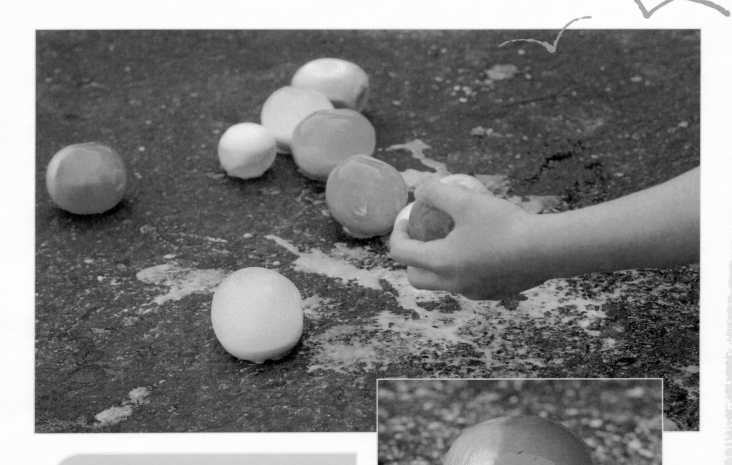

HOW IT WORKS

Your frozen marbles will be slightly bigger than the chalk bombs you put in the freezer. This is because water expands as it freezes. Most substances shrink when they freeze, but water expands because of how ice molecules crystallize with more open space.

4. There are so many ways to use chalk bombs and frozen marbles. Draw chalk targets and see how close you can land a chalk bomb to the bull's-eye. Use the frozen marbles to draw or play a giant game of shooters. Have throwing contests or races. Then go inside and make another batch!

Candy Chalk & Edible Chalkboards

This sweet chalk project is a fun way to celebrate the back-to-school season, or it makes a perfect after-school activity and snack all rolled into one. Almost any ice cube tray or mold will work, but an ice stick tray (used to make ice that fits into water bottles) makes more realistic-looking chalk. This recipe makes several sticks of chalk and small chalkboards.

INGREDIENTS
- 6 ounces white candy melts, white chocolate chips, or white melting chocolate
- 12 ounces black fondant
- Powdered sugar

SUPPLIES
- Microwave
- Glass measuring cup
- Ice stick tray (used to make ice for water bottles)
- Rolling pin
- Pizza cutter or sharp knife

DIRECTIONS
1. Place a handful of candy melts into a microwave-safe measuring cup.

121

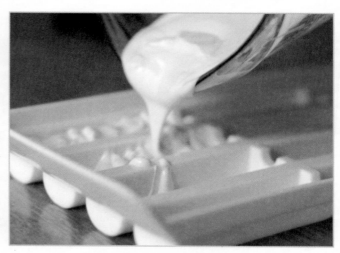

2. Microwave the candy at 50 percent power for 1 minute. Stir. Continue to microwave at 30-second intervals, and stir until the candy is melted and smooth. Repeat with the remaining candy. (Melting the candy in small batches ensures that it doesn't harden before it is poured into the molds.)

3. Pour the melted candy into the ice stick tray. Gently tap the tray on a hard surface several times to smooth out the candy and release any air bubbles. Set aside.

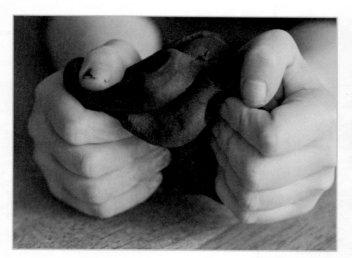

4. While the candy is cooling, knead a handful of fondant until it's soft.

5. Cover your work surface and rolling pin in powdered sugar, and roll the fondant into a smooth sheet. The powdered sugar keeps the fondant from sticking and makes it look like a real chalkboard. Use a pizza cutter or knife to cut the fondant into a rectangle.

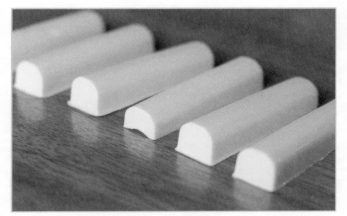

6. Check the candy chalk. When it's completely cool, gently twist the ice stick tray to remove the hardened candy from the molds.

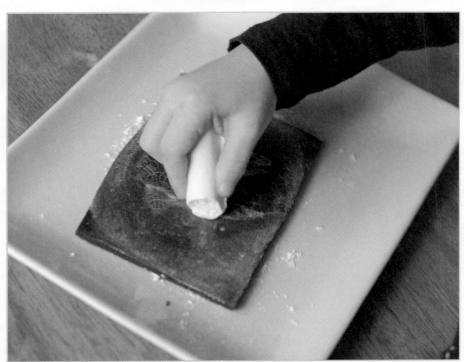

7. Your candy chalk and edible chalkboard are now ready to use! If the fondant tears when you try to write on it, roll it again and make it thicker or allow it to sit for a longer period of time. The longer the fondant is exposed to air, the harder it becomes. If you'd like to reuse your chalkboard, simply knead the fondant again until it's soft and the chalk marks are incorporated into the dough. Roll, cut, and you've got a fresh chalkboard.

HOW IT WORKS

Although real chalk is mostly calcium carbonate—an ingredient used to make antacids—you don't want to eat it. The chalk could contain other harmful ingredients, and eaten in large doses, it can cause health problems.

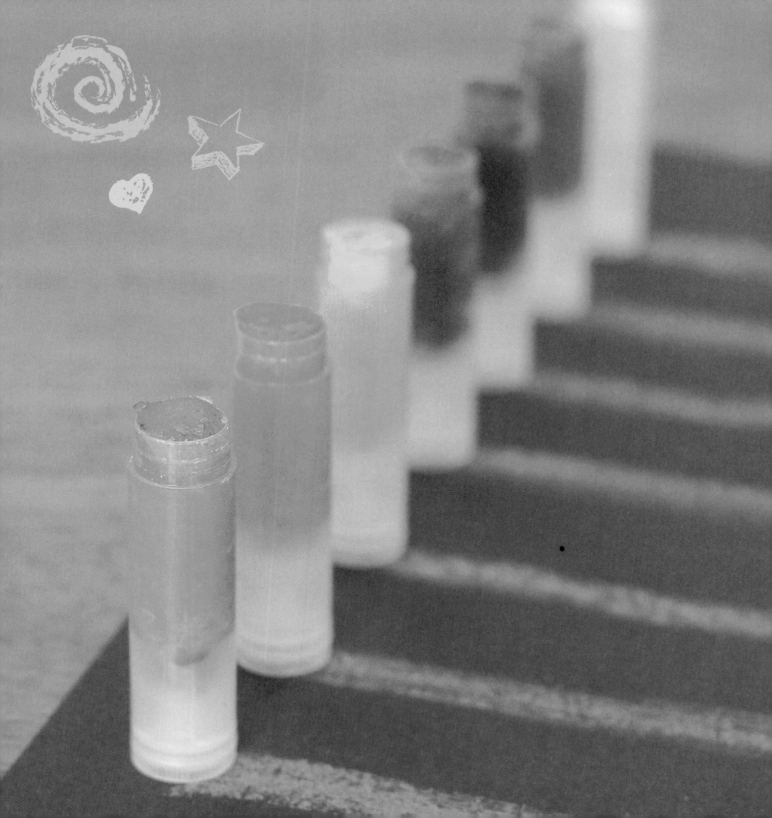

Less Mess Soft Chalk Pastels

Genuine chalk pastels can be tricky to make at home. This simple recipe is a great substitute. These faux chalk pastels can be smudged when wet, and they dry to a beautiful chalky finish. Putting the mixture into lip balm containers makes the recipe more forgiving and keeps the mess to a minimum. Each recipe makes just one or two tubes. Make as many or as few colors as you like. You can substitute food coloring for liquid watercolors, but there is more risk of the colors staining clothing and hands.

INGREDIENTS
- ½ teaspoon flour
- 1½ teaspoon plaster of paris*
- ½ teaspoon washable liquid watercolor
- Water
- Petroleum jelly

*It's important to handle plaster of paris carefully and with adult supervision. Avoid getting it in your eyes or inhaling it. Wear eye protection, gloves, and a mask if necessary. Be sure to read the label before using. It should never be poured down the sink.

SUPPLIES
- Empty lip balm containers, 1 for each color
- Disposable cup and spoon, 1 for each color
- Measuring spoons
- Disposable gloves
- Dropper
- Cotton swab

DIRECTIONS
1. Set out one disposable cup for each color of pastel you'd like to make. Use a plastic spoon to stir together ½ teaspoon of flour and 1½ teaspoons plaster of paris in each cup.

2. Add ½ teaspoon liquid watercolor to each cup, and stir well. The mixture will be very crumbly. Use the dropper to add a small amount of water to each cup. Stir. Keep adding water and stirring just until the mixture sticks together. Add as little water as possible.

HOW IT WORKS

Some historians believe that prehistoric people made art materials similar to chalk pastels. Colors from charcoal, ochre, and natural chalk were ground, mixed, and rolled or packed into hollow animal bones or seashells.

3. Use the cotton swab to coat the inside of the empty lip balm containers with a layer of petroleum jelly.

Your new chalk pastels will look especially vibrant when used on dark paper. Periodically dispense more by twisting the bottom of the lip balm container. If you keep the pastels capped when not in use, they will stay soft for a longer period of time. The flour in the recipe keeps the plaster of paris from becoming too hard, but it also may cause the pastels to develop mold. If this happens, it's time to discard them and make new pastels. Experiment with different amounts of water and paint to get the texture and colors just right.

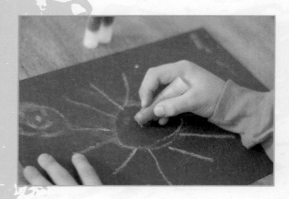

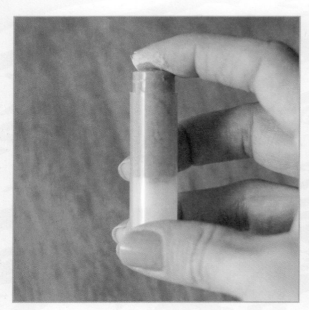

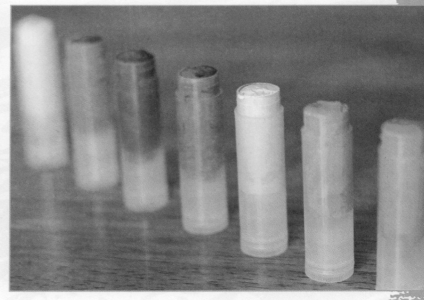

4. Push the chalk mixture firmly into the lip balm tube. Use your finger to force out any spaces or air bubbles in the tube. Wearing disposable gloves for this step is a good idea.

5. Repeat for each color of chalk pastel. Place the cap on each container, and allow to set for 24 hours before using. Storing them in the refrigerator may extend the life of your chalk pastels.

Chalk Chromatography

Many paint and marker inks are made from a combination of different colors. In this easy science experiment, watch as the colors of the paint or ink are separated again in a process called "chromatography." Black and brown inks often reveal the most interesting results, while primary colors are unlikely to separate at all.

INGREDIENTS
- White chalk sticks, one for each color
- Washable liquid watercolors, food coloring, and washable markers in various colors
- Water

SUPPLIES
- Muffin tin
- Paintbrush
- Labels

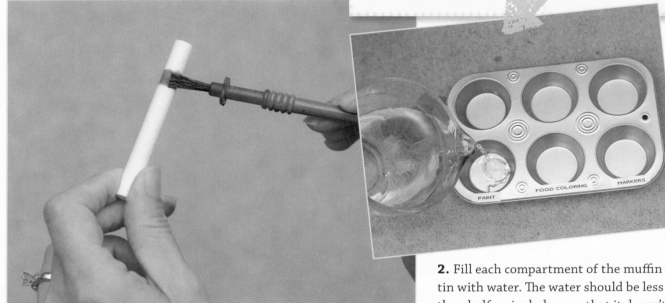

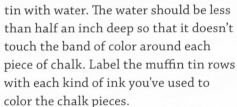

DIRECTIONS
1. Paint or draw a line around each piece of chalk in different colors. The line should be approximately a half-inch from one end of the chalk.

2. Fill each compartment of the muffin tin with water. The water should be less than half an inch deep so that it doesn't touch the band of color around each piece of chalk. Label the muffin tin rows with each kind of ink you've used to color the chalk pieces.

129

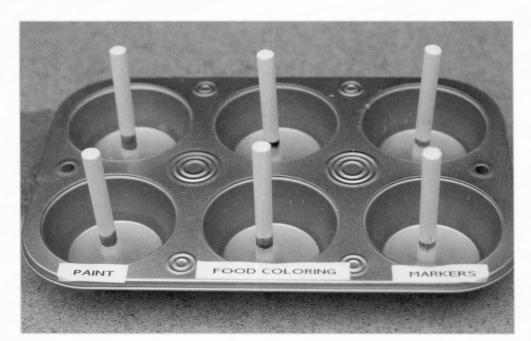

3. Stand each piece of chalk in the water.

HOW IT WORKS

As the chalk soaks up the water, different colors are carried along at different speeds. Some color molecules are smaller and lighter and get carried faster and farther than others.

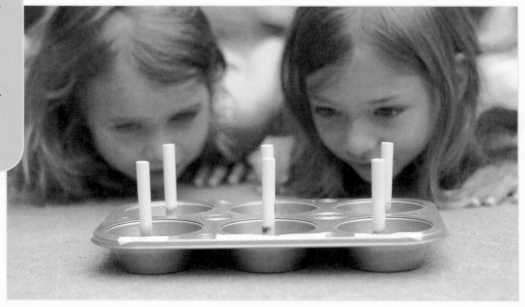

4. Watch as the water is absorbed into the chalk. The colors in the ink will begin to separate and creep up the chalk. This may take a few minutes.

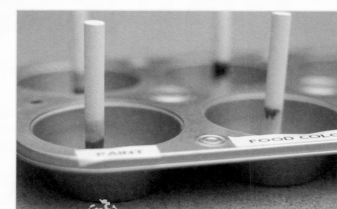

5. Notice the differences between the colors and the kinds of inks you used. Do certain kinds of dye separate more easily than others?

❋ TIP ❋

If you liked this experiment, try other science activities involving chalk. See if there is a bubbly reaction when you submerge different kinds of chalk in liquids like lemon juice or vinegar. Or try sprinkling salt onto a batch of ice chalk. Does the ice melt faster or slower? Come up with your own chalk experiments and test them out!

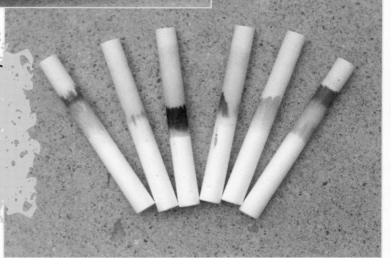

6. Remove the chalk from the water when you're finished observing.

7. You can use the chalk again after this experiment. In fact, it may have completely changed color from the ink!

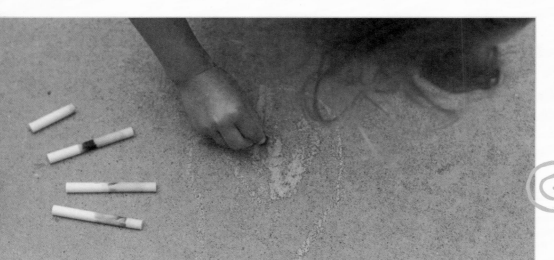

131

Hair Chalk

Why buy expensive hair chalk when you probably have all the ingredients you need to make a rainbow of temporary hair color at home? This is a fun activity for a slumber party or a great addition to almost any Halloween costume. Color just the ends of your hair for a more subtle effect, or go wild with multicolored streaks on each strand.

INGREDIENTS
- Non-toxic chalkboard chalk, one stick for each color
- ½ tablespoon clear hair gel for each color
- Water

SUPPLIES
- Bowl or cup for water
- Fine grater or zester
- Bowl or cup for mixing
- Mixing spoon
- Measuring spoons
- Capes or old towels to protect clothing and surfaces

DIRECTIONS
1. Soak the chalk in water for 5 minutes. This will soften the chalk slightly and reduce the amount of dust created in the next step.

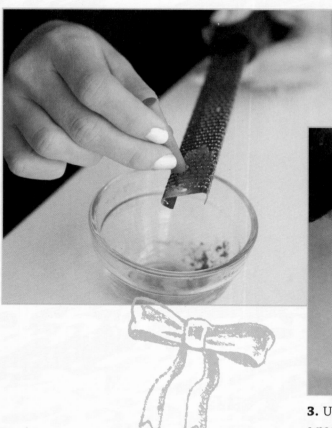

2. Finely grate the chalk into a small bowl. One small stick of chalk should make about 2 teaspoons.

3. Use the spoon to stir and mash the grated chalk into a paste.

4. Add clear hair gel, and mix until blended. Repeat until you've made the desired number of colors.

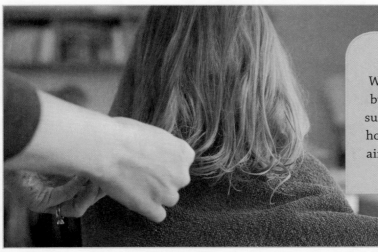

5. Protect clothing and surfaces before applying the hair chalk. Use your fingers to rub the chalk gel into the hair. For a softer effect, brush through the hair once the gel has set.

6. Setting the color with heat (like a blow dryer or flat iron) will make the color last longer. Always be sure to test the color on an inconspicuous area first to be sure it doesn't stain. Blond hair is more likely to hold the color through a few shampoos. Wearing your hair in an updo or braid will help prevent the chalk from rubbing off on your clothes.

Chalkboard Paint

Once you've made a batch of chalkboard paint, you can turn almost any surface into a chalkboard. Best of all, you can make it any color you'd like. This recipe is so easy that you'll soon be painting everything in sight! Just be sure to make only what you'll use right away because it doesn't store well.

INGREDIENTS
- 1 tablespoon warm water
- 1 tablespoon plaster of paris*
- 2 tablespoons acrylic craft paint

*It's important to handle plaster of paris carefully and with adult supervision. Avoid getting it in your eyes or inhaling it. Wear eye protection, gloves, and a mask if necessary. Be sure to read the label before using. It should never be poured down the sink.

SUPPLIES
- Paintable surface, such as squares of wood or paper sticker labels
- Disposable cup and spoon
- Measuring spoons
- Paintbrush
- Newspaper
- Plastic wrap
- White chalkboard chalk

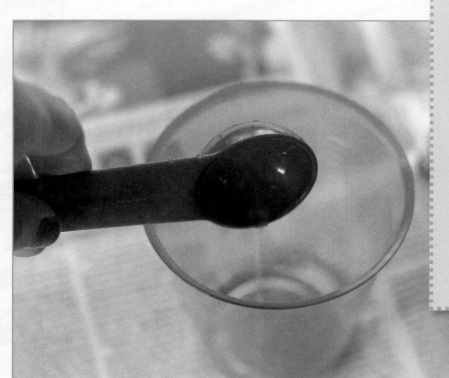

DIRECTIONS
1. Cover your work surface in newspaper because acrylic paint can stain. Pour warm water into a disposable cup.

2. Add plaster of paris, and mix until the lumps are gone. Add acrylic paint, and stir until completely smooth.

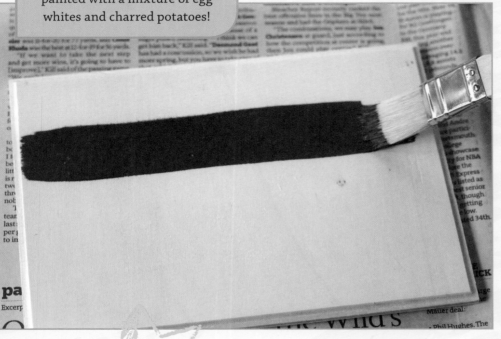

3. Using the paintbrush, apply three thin layers of paint to the surface. Allow to dry for at least an hour in between each layer. Cover the paint with plastic wrap while waiting for the layers to dry.

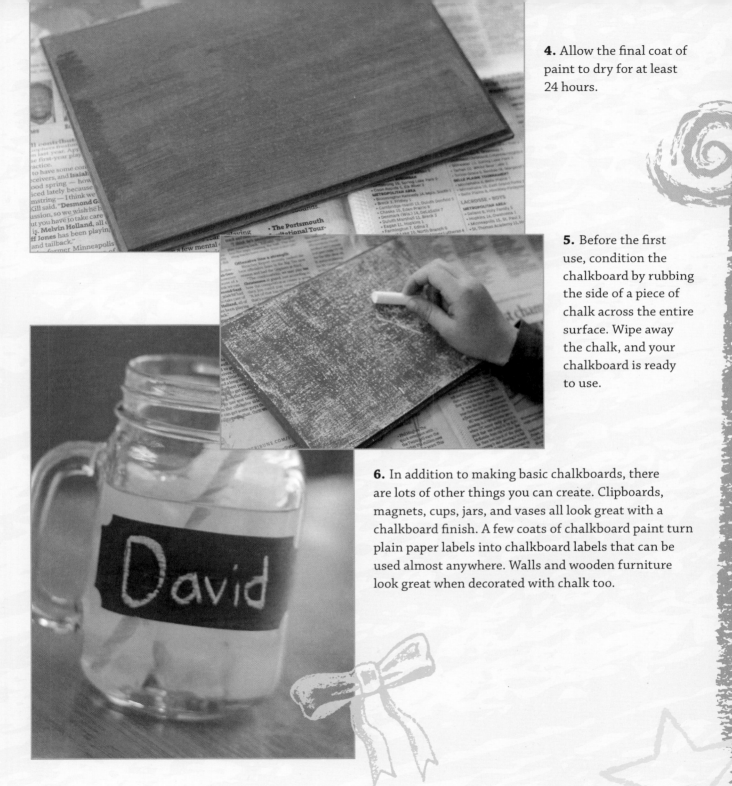

4. Allow the final coat of paint to dry for at least 24 hours.

5. Before the first use, condition the chalkboard by rubbing the side of a piece of chalk across the entire surface. Wipe away the chalk, and your chalkboard is ready to use.

6. In addition to making basic chalkboards, there are lots of other things you can create. Clipboards, magnets, cups, jars, and vases all look great with a chalkboard finish. A few coats of chalkboard paint turn plain paper labels into chalkboard labels that can be used almost anywhere. Walls and wooden furniture look great when decorated with chalk too.

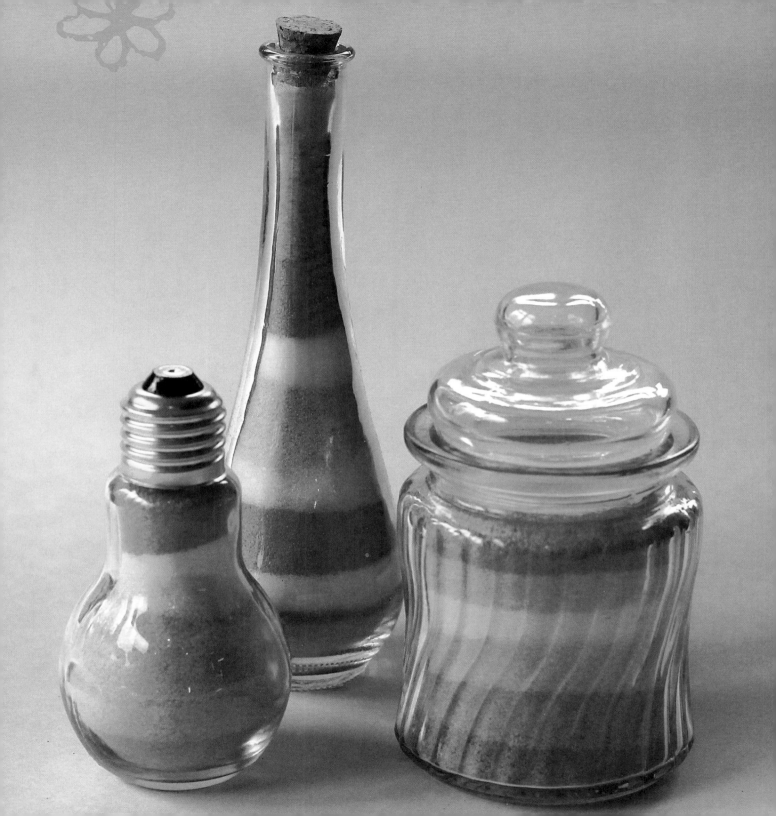

Powdered Chalk Containers

Create colorful chalk decorations with supplies you probably already have on hand. Almost any clear container will work, so look through the recycling bin and give new life to old jars. Homemade or store-bought chalk works equally well for this project, but it can get messy, so you may want to take it outdoors.

INGREDIENTS
- Chalk, one stick for each color
- Table salt, enough to fill the container, plus extra

SUPPLIES
- Clear container with a lid
- Metal or plastic tray (don't use your best—the salt may scratch it!)
- White paper, one sheet for each color
- Funnel

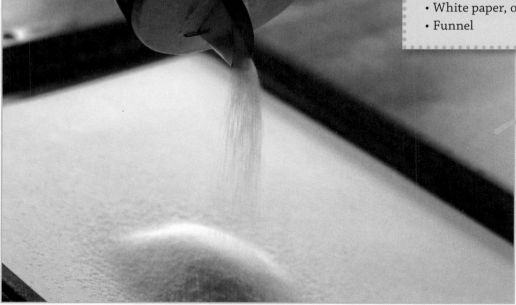

DIRECTIONS
1. Place a sheet of paper on the tray. The tray will keep the salt from spilling, and the paper will make it much easier to transfer the powder. Pour a small amount of salt onto the paper. The amount of salt depends on the size of the container and how thick you want each layer of color.

2. Rub the chalk over the salt until you achieve the desired color. Rub in different directions, and be sure to color all the salt. The longer you rub the chalk on the salt, the more saturated the color will be.

HOW IT WORKS

The most common variety of salt is sodium chloride, the same white table salt used in this activity. Salt crystals are shaped like tiny cubes with sharp, squared edges. When rubbed against chalk, the salt crystals scratch and grind the chalk into a fine powder, mixing and coloring the edges of the salt crystals. Be careful—the salt crystals are even sharp enough to scratch the pan!

3. Use a funnel or fold the paper into a funnel shape and pour the powder into the container. You may have to shake the container gently so the chalk settles into an even layer.

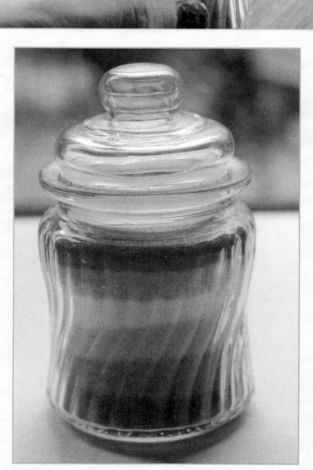

4. Repeat with other colors. Change the paper each time and clear any salt from the tray so you don't contaminate other colors. Once the container is full, add the lid.

✻ TIP ✻

If you're unsure of how much to use, pour the salt into the container to check the level before pouring it onto the paper. This will also give you an idea of how much to use for the rest of the colors.

5. If you're planning to make a rainbow of colors remember to start with purple first, but don't limit yourself. Have fun experimenting with different patterns and color combinations. Try coloring the same batch of salt with more than one color of chalk. Or give your finished container a gentle shake to achieve a tie-dyed effect.

Lorie King Kaehler

Lorie King Kaehler has worked with children as a reading specialist and middle school teacher for more than 10 years. After her son and daughter were born, she took a leave of absence to be home with them during their preschool years. It was during this time that she started her blog, *Reading Confetti*. The blog, originally created to share ideas with other parents for creating lifelong readers, has evolved to include many different kinds of projects and activities for kids. *Reading Confetti* has been featured in magazines such as *FamilyFun* and *Scholastic Teacher*. Now that her children are starting school, Lorie has returned to the classroom as a reading specialist at the elementary level. Lorie lives in Minnesota with her husband and kids, but makes frequent trips to Wisconsin to visit her extended family. The two months of the year she's not shoveling snow, she enjoys reading, planning parties, and watching reality television.

Donna Starry

Donna Starry has always loved photographs but became especially interested in photography after her first son was born. Her other hobbies include scrapbooking, playing piano, and volunteering at her children's school. In 2014, she earned a black belt in Tae Kwon Do. Donna has a teaching degree in Broad Field Social Science for the middle and high school level. She lives in Wisconsin with her husband and four children but makes frequent trips to Minnesota to visit her sister and extended family.